D1133826

CREATIVE
COLLAGE

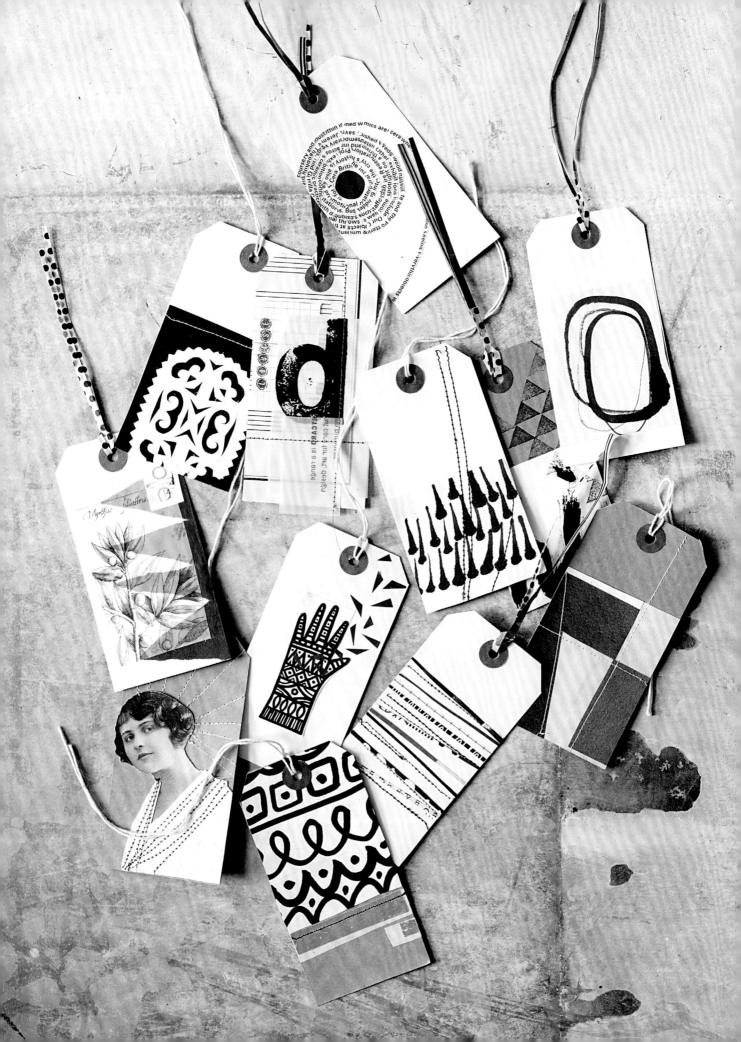

CREATIVE COLLAGE

30 PROJECTS TO TRANSFORM YOUR COLLAGES INTO WALL ART,
PERSONALIZED STATIONERY, HOME ACCESSORIES, AND MORE

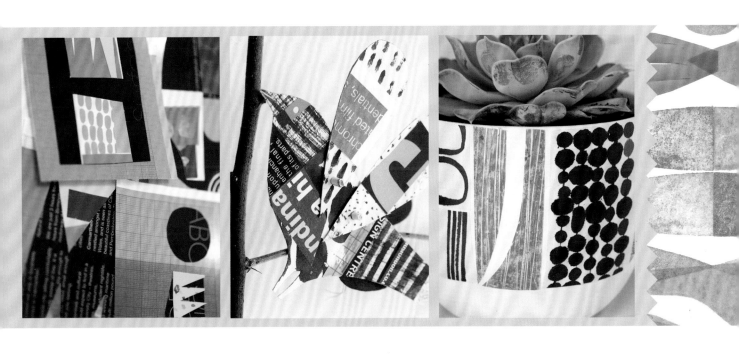

Clare Youngs

CICO BOOKS

LONDON NEW YORK

Published in 2017 by CICO Books
An imprint of Ryland Peters & Small Ltd
20–21 Jockey's Fields 341 E 116th St
London WC1R 4BW New York, NY 10029

www.rylandpeters.com

10 9 8 7 6 5 4 3 2 1

Text © Clare Youngs 2017
Design, illustration, and photography
© CICO Books 2017

A CIP catalog record for this book is available
from the Library of Congress and the
British Library.

ISBN: 978 1 78249 489 8

Printed in China

Editor: Anna Southgate
Designer: Elizabeth Healey
Photographer: Jo Henderson
Illustrator: Ian Youngs
Stylist: Clare Youngs

In-house editors: Carmel Edmonds and
Anna Galkina
Art director: Sally Powell
Production manager: Gordana Simakovic
Publishing manager: Penny Craig
Publisher: Cindy Richards

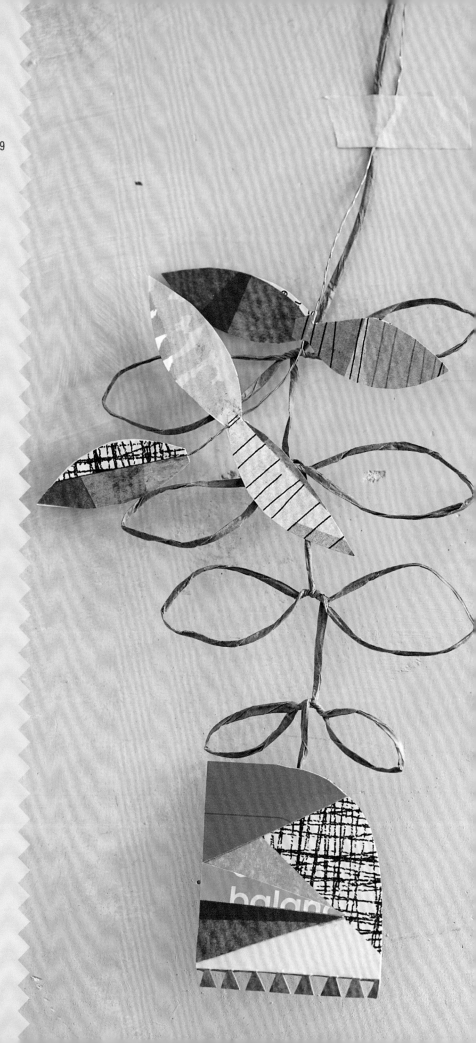

CONTENTS

Introduction 6

CHAPTER 1
Getting Started 8
Basic tools and techniques 10
Decorative papers 13
Collecting ephemera 18
Composition 21
Layering 26

CHAPTER 2
Collage Projects 28
Collage a cabinet 30
Colorful cockatoo wall art 33
Framed layers 36
Little boxes 39
Little notebooks 42
Photo wall hanging 45
Textural bird 48

Travel journal 51
Large-scale abstract 54
Collaged tote 58
Luggage-label gift tags 60
Abstract pots 64
Wildlife cutouts 66
Bright abstract pillow 70
Fishy place mat 73
Giftwrap 76
Armadillo fabric wall hanging 78
Fruity cutouts 81
Photo montage 84
Scrap-paper critters 87
Montage mobile 90
Geometric bird 92
Names in lights 95
Decorative flowers and leaves 98
Party bags 101
Stacking block collage 104
Folded lampshade 106
Snail mail 110
Party garland 113
Spring bouquet 116

Templates 118
Suppliers 128
Index 128
Acknowledgments 128

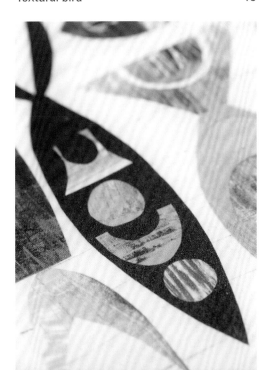

INTRODUCTION

I have had a love for all things paper-related since I was a child, so it is no wonder that I find collage an endlessly creative and exciting way to work. At the age of seven, I made a collaged hedgehog that won a competition, and I haven't stopped since. Recently, I have been enjoying the challenge of making **a collage a day for a 100-day project** on Instagram. Picking up a pair of scissors and **cutting up pieces of paper**, moving them around, and then sticking them down is an art form that is **expressive**, **liberating**, and, above all, **fun**!

Great artists who made collage part of their lifetime's work have always inspired me. Although the techniques have been used since the invention of paper in China around 200 B.C.E., the word "collage" was first used in connection with art by Georges Braque and Pablo Picasso at the beginning of the 20th century, when the technique became an important part of the Modern Art movement. I love the work of Peter Blake, who codesigned one of the most famous and iconic collages—the cover sleeve to Sgt. Pepper's Lonely Hearts Club Band by the Beatles. I find his collaged pieces fascinating, especially his use of ephemera. I have been collecting vintage matchbox labels for many years; I have thousands and use them in my collages. In his later years, Henri Matisse created the most beautiful artworks from cut paper. He said it was drawing with scissors. I love that.

We can stand back in awe at the work of great artists, but in fact collage is something that anyone can enjoy. It is inexpensive, you don't need a lot of equipment, it frees your mind, and allows you to release creativity within you that you didn't even know was there. Great things happen when you let go a bit—what's not to love?

The first section of this book is about getting started—from making your own collection of hand-painted papers to finding imagery and ideas for making quick collages. You can dive straight in to explore the possibilities that collage opens up, and then use the second part of the book for ideas on displaying your art and on how to use your collages in a variety of projects. Follow step-by-step instructions to transform an old cabinet, turn collages into pillows, and learn how to collage on wood; create a piece of wall art to display your favorite photos or make stunning giftwrap and tags. You can mix and match the projects. You may love the collage ideas on one project and apply them to another. Or one project might spark off a series of artworks that are perfect for framing. I hope you find inspiration throughout the book, that you come to share in the excitement that I get from cutting and pasting, and that it gives you the confidence to create collages as individual as you are.

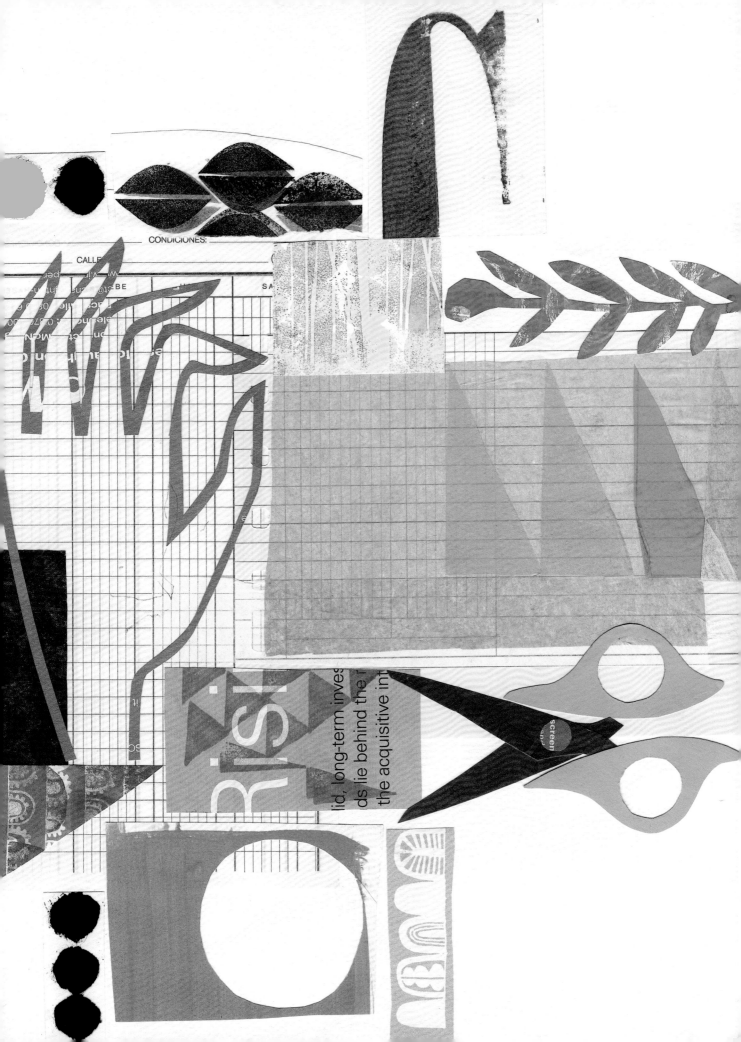

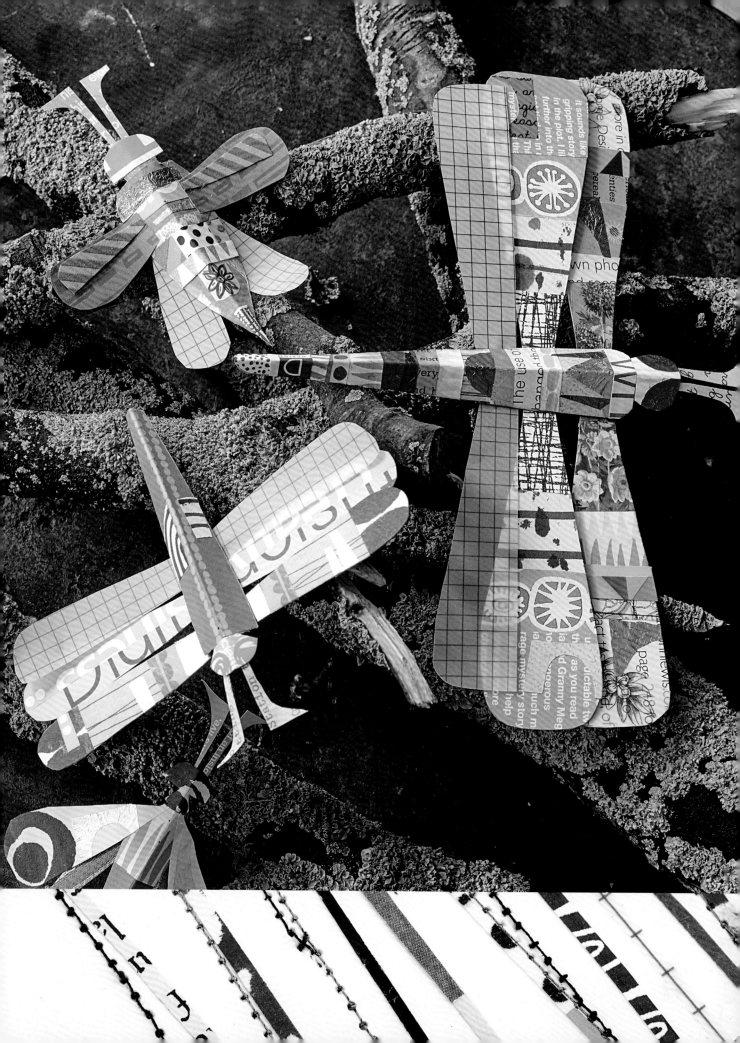

GETTING STARTED

BASIC TOOLS
AND TECHNIQUES

Essentially, all you really need for making a collage is **paper**, **scissors**, and **glue**. For the projects in this book, I have proposed working with a wide selection of different papers—**and even fabrics**—in order to produce a diverse range of effects and end results.

PAPER

There are numerous types of paper you can use: painted paper samples; craft paper, plain and patterned; collected paper (from old books or magazines, maps, postcards and photographs, giftwrap); tracing paper; graph and lined paper; white printer paper; drawing (cartridge) paper; thin white card stock (card); gray board.

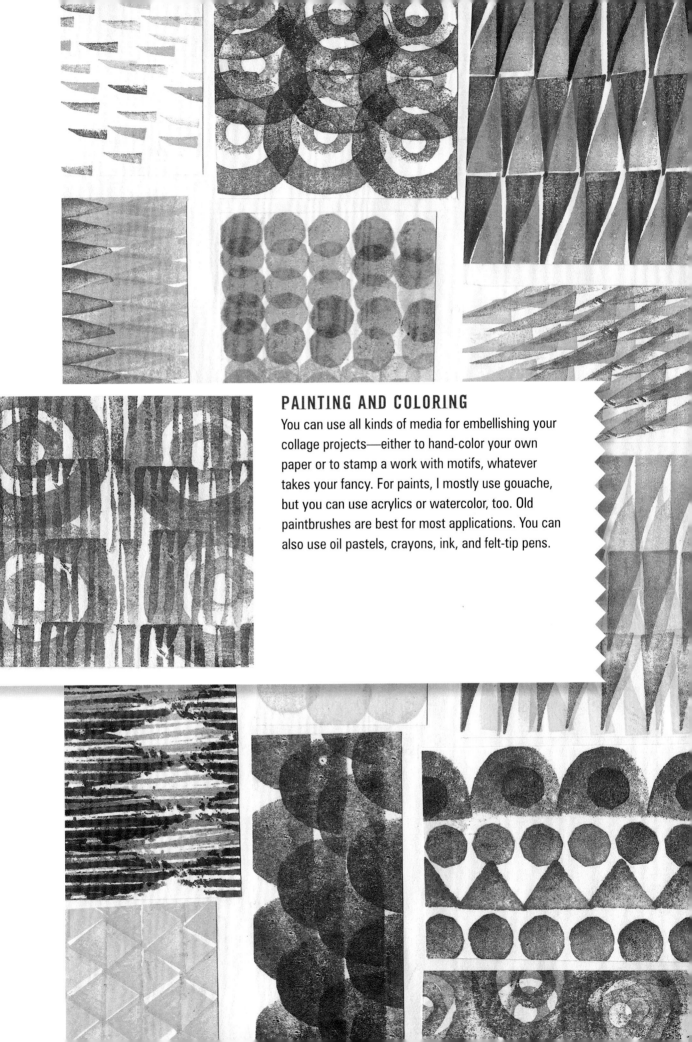

PAINTING AND COLORING

You can use all kinds of media for embellishing your collage projects—either to hand-color your own paper or to stamp a work with motifs, whatever takes your fancy. For paints, I mostly use gouache, but you can use acrylics or watercolor, too. Old paintbrushes are best for most applications. You can also use oil pastels, crayons, ink, and felt-tip pens.

RUBBER STAMPS

Rubber stamps are great for embellishments. Use simple shapes, cut from an eraser or sheets of easy-cut rubber from a craft supplier. Cut shapes using a craft knife, and use a lino-cutting tool to cut lines, dashes, and dots into the surface.

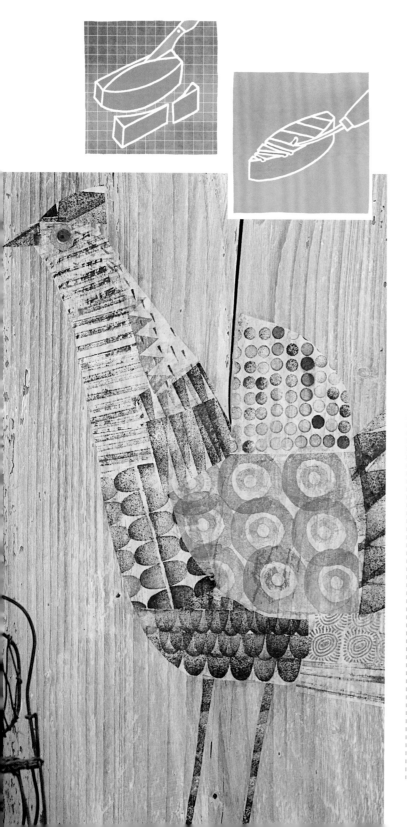

MEASURING

A sharp pencil and metal ruler are best for measuring, although any ruler will do. Use a triangle (set square) for shapes that require precise angles or corners.

CUTTING AND SCORING

I like to use small paper scissors with sharp pointed ends for precision cutting. A larger pair of scissors is good for cutting cardboard and heavier materials. I also use a scalpel or craft knife for many projects. Make sure the blade is sharp and that you always use a cutting mat. When you need to make a straight cut, use a metal ruler and keep the blade in contact with the ruler at all times. Cut toward you, maintaining an even pressure. Some projects involve scoring lines, rather than cutting, to help create neat folds. Use a paper scorer or a blunt knife for this.

TAPE AND GLUE

Masking tape is useful for holding tracing paper in place when making a template. When it comes to glue, I use different types for different jobs. Mostly, I use a glue stick. Try to find one with clear glue, as these are less likely to clog up. PVA is a good all-purpose glue that dries clear. This is the best glue for sticking tissue paper. Water it down slightly then apply the glue to the collage surface and place the tissue paper down on top. If using spray adhesive, be sure to follow the instructions properly. I have used acrylic medium as a transfer medium for some projects. You can also use it as a glue, and to add a protective layer on top of your collage.

FINISHING

A bone folder, or a printmaker's roller, is good for flattening images once they have been stuck in position. You can use washi tape to great decorative effects—sticking a project to the wall or adding a frame, for example.

DECORATIVE PAPERS

The **papers that I create myself** form an important part of my collage work. They add **color, texture,** and a **vibrancy** that turns an average collage into something really exciting. Here is a chance to make your collages individual and to **start building your own unique style**. This is a really fun aspect of collage. It is hugely creative and you can lose yourself in the **art of making marks**. It takes no time to build up a collection of paper samples, ready to be cut up and pasted into your creations.

USING GOUACHE

I use gouache paints mostly. They come in a wide variety of colors and can be mixed to provide any shade and hue you could possibly want. I spend hours filling blank sheets of paper with areas of flat color to cut up, as well as making all manner of stripes, dots, blots, and grids. I keep a handful of old brushes that I am not precious about, and these create lovely effects. For a painterly, textured area, scrunch the brush down and let it splay out, for example, or use a slightly drier mix of paint for other textures. Painting patterns in bright colors onto colored paper produces some great samples, too. Sometimes, I paint over areas of text on pages ripped from old magazines—I love the contrast of wobbly lines and splodges overlaying the regimented rules of lettering.

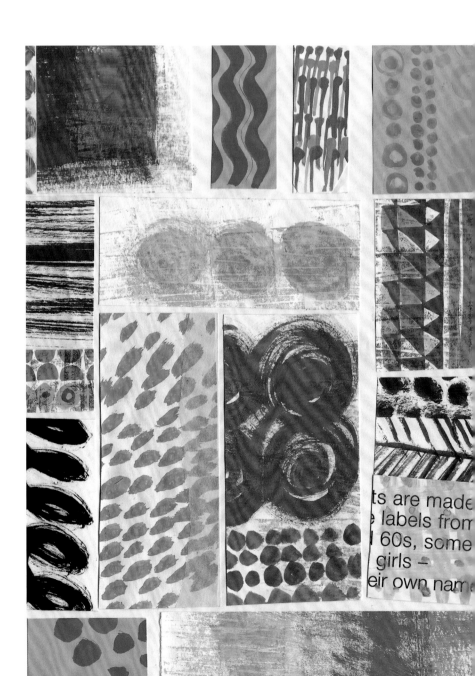

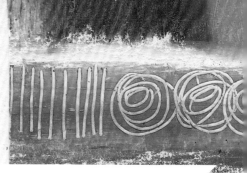

OIL PASTELS

Oil pastel colors can be laid down, one on top of another and the top layer scraped away to make patterns. Use something pointed like a darning needle. I even put the tiny rolls of oil pastel that rub off when making a large area of color to use; I scoop them up onto a piece of white paper and rub and press them onto the paper with a finger, to produce a smudgy, dotty delight!

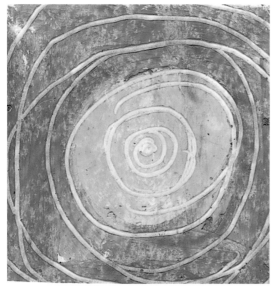

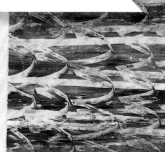

OTHER MEDIA

With felt-tip pens, I love using bright neon colors. They work brilliantly on tracing paper to use on layered collages (see Layering, page 26). A good, old-fashioned bottle of black ink is also a wonderful thing! I make up sheets of squiggles and swirls, and patterns with ink, using paintbrushes and dip pens. I also use crayons, pencils—anything and everything that will make a mark.

Once you have a good collection of papers, cut some up to create some fish like these. They are made with a mix of painted paper, felt-tip, and ink samples. Don't think too hard about it—just get cutting and sticking. These fish would be wonderful as a mobile, attached to string and hung in groups from the ceiling.

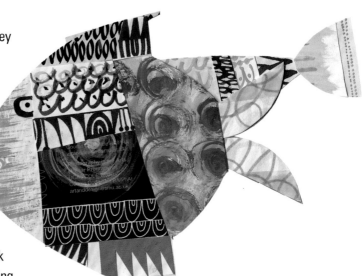

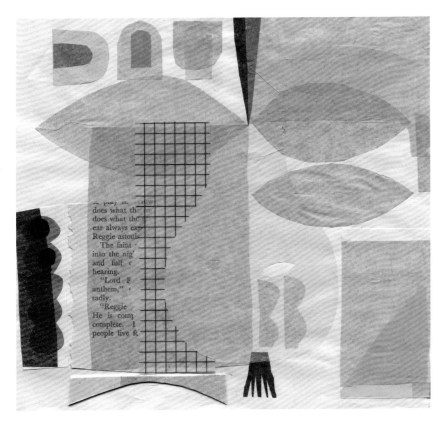

SPECIAL PAPERS

Try using different papers for your mark-making, I love printing onto tissue paper. These printed pieces of paper are wonderful to use in layers, creating areas of rich texture and overlapping color. Graph paper is fun to print onto, as well, so that some of the grid shows through the slightly translucent ink. Overlay a print in different colors for more texture.

TYPOGRAPHY

Start collecting typography—interesting areas of text, single letters, or pages from old books. Print some from your computer onto different colored paper, graph, or tracing paper. You can buy alphabet stamp kits that are a wonderful way of adding words to make your collages more personal. Try making a collage using just typography. It can be purely abstract or figurative—say a face made using only letters. This would make a wonderful card for a friend, especially if you use the letters of their name and, perhaps, the date of a celebration.

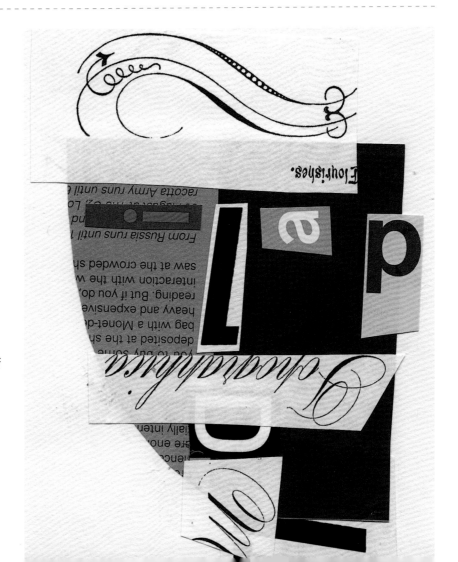

PHOTOGRAPHS AND POSTCARDS

Photographs and old postcards make ideal bases for collages. I like to use black-and-white images, so that the collaged section really pops. This is a great way to use all those images that you have stored on your phone or those old snaps tucked away in drawers, that haven't seen the light of day for years. Simply cutting up a photograph in strips and rearranging them can produce an exciting altered effect. Or try adding some geometric shapes to a photo. The contrast between blocks of color and black-and-white images makes a striking arrangement. Vintage black-and-white photos make a wonderful starting point. Old books are a good source, and if you don't want to take the pictures out, you can scan and print them instead. There is usually a box of old photographs and postcards to be found in a thrift store or at a flea market. I love rummaging through and wondering who all those characters were. Taking such a photograph and adding your touch opens the image to new interpretations. For ideas on how to use your photographs look at the projects on pages 45, 84, and 104.

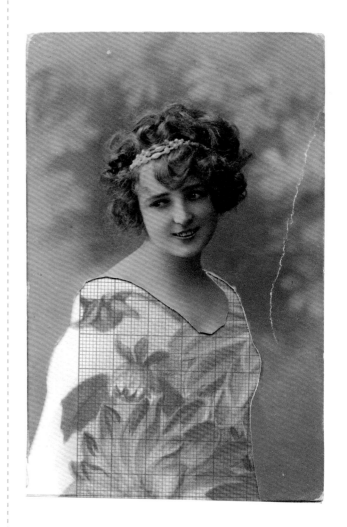

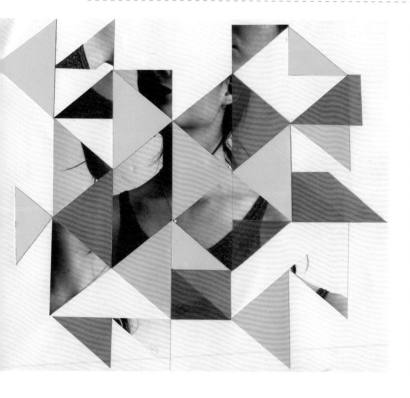

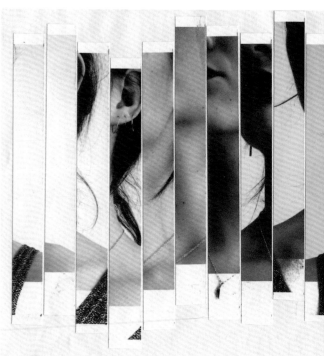

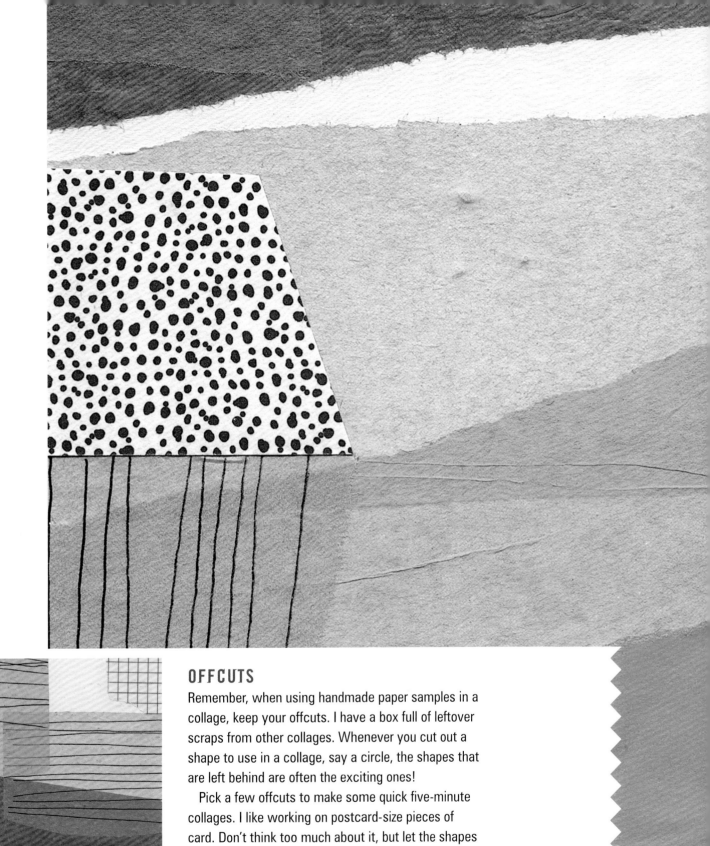

OFFCUTS

Remember, when using handmade paper samples in a collage, keep your offcuts. I have a box full of leftover scraps from other collages. Whenever you cut out a shape to use in a collage, say a circle, the shapes that are left behind are often the exciting ones!

Pick a few offcuts to make some quick five-minute collages. I like working on postcard-size pieces of card. Don't think too much about it, but let the shapes guide you—abstract or figurative, I have no doubt that something exciting will happen!

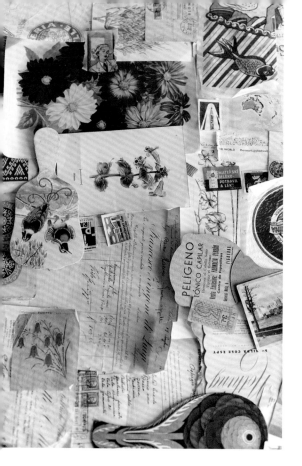

COLLECTING EPHEMERA

The most essential elements of making a collage are, of course, the pieces of paper you use. I collect ephemera—**a sophisticated word for printed paper items** that have a short-term use and are then thrown away. I have stashed away all sorts of scraps over the years and am always on the lookout for something interesting to provide the perfect starting point, middle section, or finishing touch to a piece of my work.

ANYTHING GOES

When I say any pieces of paper, I mean it. You may well have the makings of many collages already close to hand. In your bag you may have receipts, train tickets, or a shopping list. You probably have a pile of magazines that you have been meaning to sort. Look through boxes that you have stored away, for old photographs, letters, and postcards. Even boring bank statements have interesting patterns on the insides of their envelopes. If you don't want to cut something up, simply scan the imagery and print it out. This also gives you the opportunity to change the scale. A simple section of a handwritten note becomes something abstract and exciting when you print it out big.

Magazines and catalogs are always good sources of material. To save on space, rip out the pages that appeal before recycling the rest. Don't forget to rifle through the recycling at the same time! I have rescued gorgeous bits of giftwrap, and even the odd bit of junk mail with interesting typography.

Rather than using plain white paper as a background, I love to start a collage with something more interesting —I am drawn toward graph and lined paper in any form and always seek out different types. I also tear out unused pages from old exercise books. The inside covers and blank first pages of old books have a lovely lived-in look to them, their signs of wear and discoloring adding depth and interest to an artwork. Nowadays, you can choose from a huge selection of craft papers, available in art stores. These are always useful, but I think there is something very special about gathering your own material and transforming papers that would otherwise have ended up in the trash into a unique creation. Look at the project Framed Layers (pages 36–38), for an example of using ephemera.

LOOKING FARTHER AFIELD

Look for interesting bits and pieces when out and about: sections of packaging, paper bags, or printed napkins. To the dismay of my children, I have found some of my favorite scraps digging around in the trash cans at the end of a food market. I have come away with lovely tissue fruit wrappers and brightly printed graphics that were stapled to the sides of wooden crates; even the boxes themselves can be useful.

Flea markets, yard sales, secondhand bookstores— these are all good places to rummage around in. I look for books that are falling apart or are so dated that they may not be relevant any more. Old maps, music scores, travel brochures, stamp collections, and old postcards

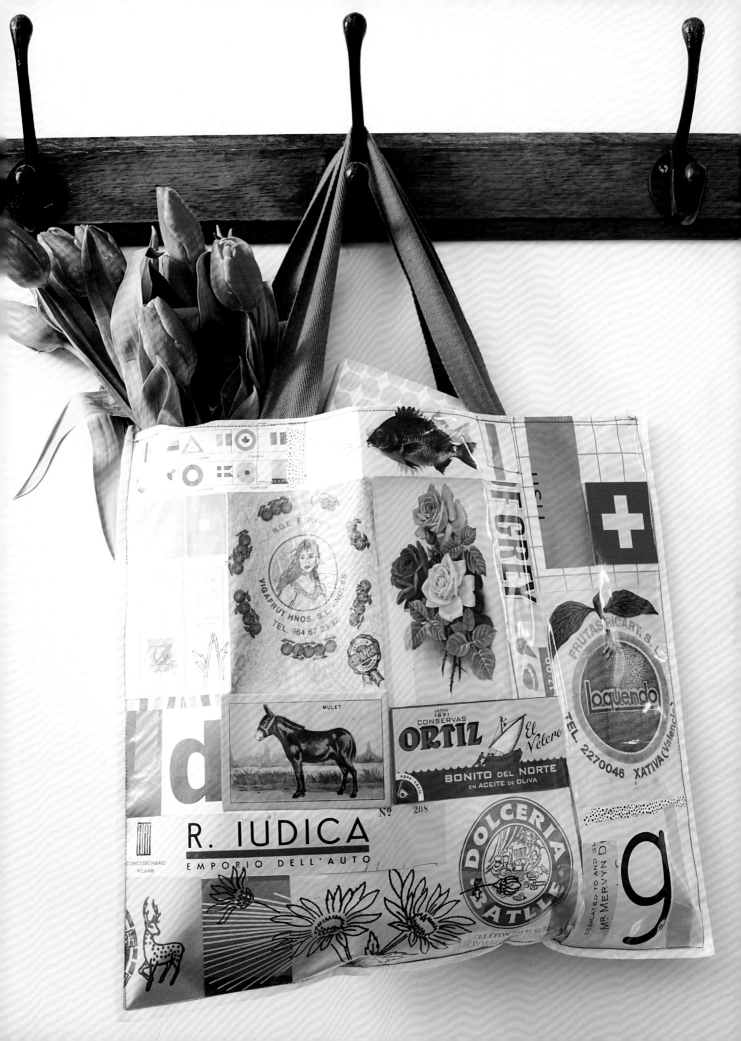

are especially worth looking out for. I recently found a box full of old beer mats. Some of the graphics were really lovely. I bought 20 of them, but now I wish I had bought many more, although there are limits to my storage facilities! If you are away traveling, be sure to seek out a flea market if you can. The ephemera you find will be very different to the pieces you see closer to home. I was in Italy recently and bought a bundle of papers from a stall in a flea market. There were some receipts for a garage filled in with the most beautiful copperplate handwriting.

DOWNLOADING ROYALTY-FREE IMAGES

There is a multitude of online sites with thousands of royalty-free images. Some offer the images free, while others charge a small fee to download them. There are also books that come with CD-ROMS containing a whole range of different images and clip art that you can use. You must take great care to use images that are copyright free. Always check before using any image in your artworks. It doesn't matter so much if the images are for your own personal use, but if you plan to show your work online, or sell it, it is better to be safe. (See page 128 for suppliers.)

STORAGE AND ORGANIZATION

Until recently, I was storing all of my paper samples in boxes. To begin with, I had some sort of system, but eventually the boxes became a big jumbled mess. I loved digging around and randomly picking out a few pieces of paper to allow a collage to take shape from the selection I had made. But this was also frustrating. Sometimes I knew I had the perfect piece to complete a collage, but where could it be?

Now I use box files, stored neatly on the shelves in my studio. I divide material into vintage ephemera, magazines, printed pattern, text, handmade pattern, handmade texture, and colors. If I want to categorize further—say, in the color file—I use separate envelopes within the same box. It is quite important to be organized with collage. It is easy for things to get out of control and, in no time, you find yourself knee deep in snipped paper!

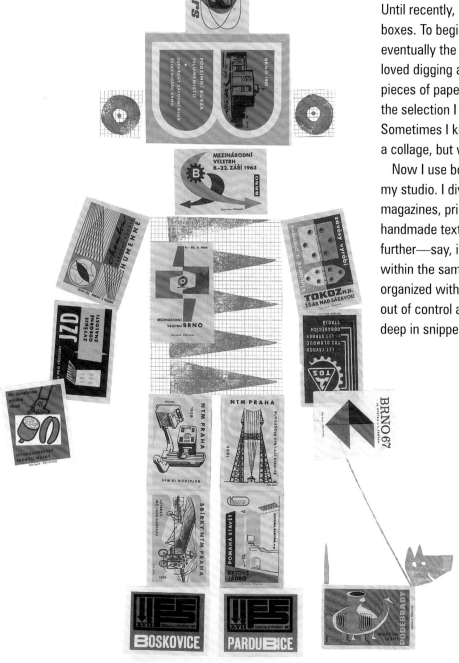

COMPOSITION

You have your selection of beautiful, handmade papers, a pile of magazines ready to snip with a pair of scissors, and your collected ephemera neatly stored in a box. Time to get going and make a collage. But sometimes, **a plain white sheet of paper can be a daunting prospect** and you don't always know where to start.

Being able to place random elements together and come up with something wonderful may come easily to some, whereas others may find a little general advice on layout and design really helpful. I realized when I started reading about the rules of a good composition, that I have been following those rules without thinking about it and I believe that is the key to creating great collages. Sometimes you simply have to let go and see where the paper takes you without thinking too hard about it.

The way I work means I rarely have an idea as to what a finished piece will look like. I like to rummage through my paper samples, pick a few, and then start playing with them, allowing an idea to emerge as I move the papers around. The colors and shapes may suggest a direction to go in and I let them lead the way. This may sound an odd way to work, but with collage it seems to be the right way. I tend to cut and place pieces down to a nearly complete stage before I stick anything. If there are overlapping pieces and layers, I use my phone to take a picture that I can refer to as I remove pieces to start sticking. Sometimes I stick a piece down and it doesn't look right—I simply pull it up or go over the area with something else. The beauty of collage is that you do not need to be precious about it. Knowing when a collage is complete is tricky, and I have to say, I think it is intuitive: It is right when it looks right. I often find the last piece of paper I stick down is a small one, almost acting as the period at the end of a sentence.

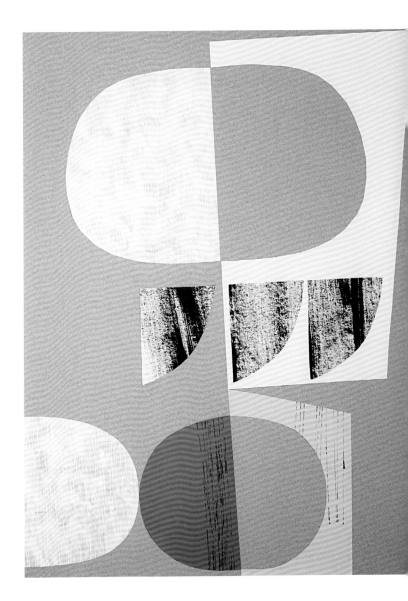

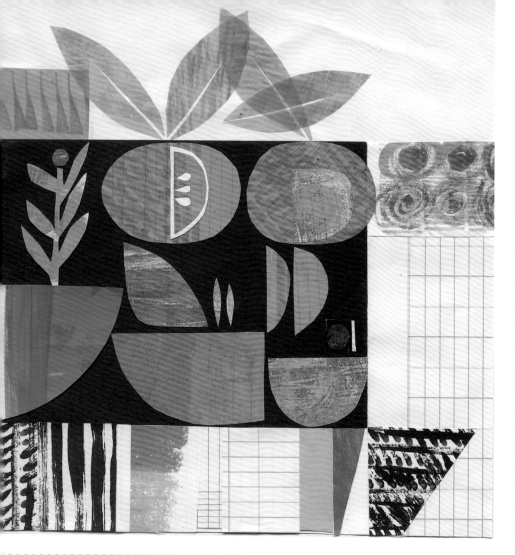

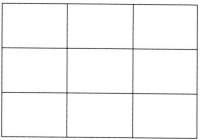

RULE OF THIRDS

This is a technique by which you divide your paper into three rows and three columns. The points at which the vertical and horizontal lines meet, are where the focal points of your collage should be. It is important to balance the areas of space and imagery. An asymmetrical balance works well. I find that, subconsciously, this is the rule I use the most. In my head, there is an invisible line one-third of the way across a collage and I work outward in each direction from this line. You can break the line, it doesn't have to be exact, but keeping things off-center in this way does make a good arrangement.

CREATING VISUAL IMPACT

Great collages can be made by playing around with random images and placing them together to make a complete picture. Flick through some old magazines and tear out several pictures. Think about the scale, for a dynamic and arresting collage. Turn things on their head by pairing something that is normally small made giant size, next to something tiny that is otherwise huge.

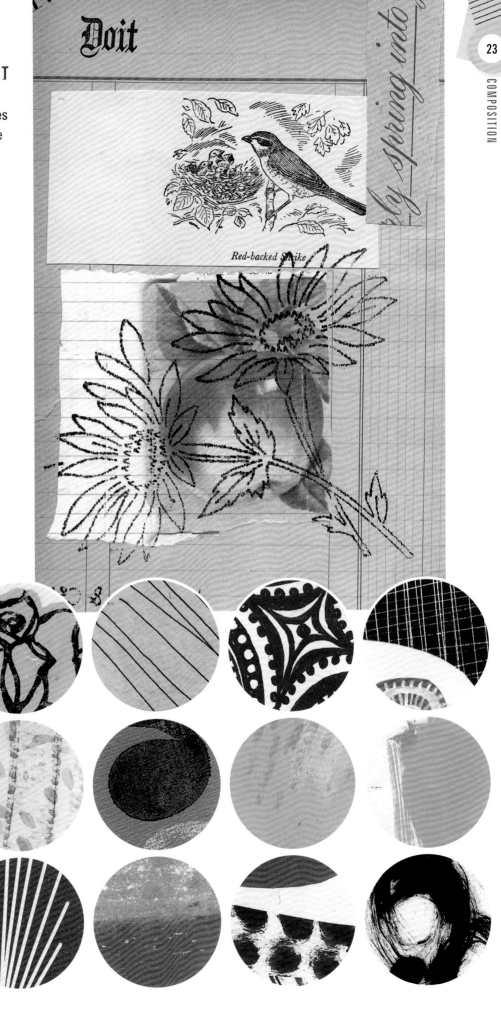

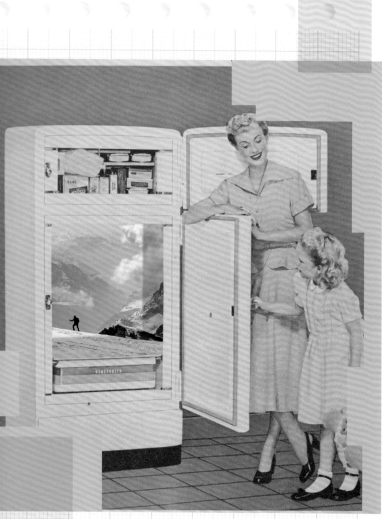

The two digital collages I have created here were from images I cut out of old magazines. I scanned them and played around with them on my computer, but they can easily be created using scissors, cut paper, and glue. It is all about creating the unexpected, a collage that is eye-catching and a visual surprise.

An area of bold color among more neutral shades can be effective, too. Spotlight an area for visual impact: Using bold shapes of translucent color over black-and-white photos is one way of doing this. See the Photo Wall Hanging, pages 45–47, for an example of this.

The repetition of a given image or shape can also make a strong visual statement. A collage made from cut triangles or circles is simple to achieve and can be visually exciting.

Think, also, about your use of color. You might want to choose a range of blues and greens (colors that blend together) or go for clashing pinks and oranges. I like making black-and-white collages for bold statement pieces. The same idea can look very different depending on the colors you use.

The main thing to remember is that, once you know about the rules of a good composition, you can break them and still make wonderful and striking works. In collage, rules are meant to be broken. The only thing that matters is spontaneity: start cutting out shapes, moving them around, and sticking them down. Just see what happens. It can be that simple.

POSITIVE AND NEGATIVE SHAPES

When I cut a shape, I usually love the offcut just as much, and will store it away for future use. Sometimes, I use both pieces on the same collage. Try this quick-and-easy exercise to make some abstract collages to get you going. It offers a great way of looking at composition! Simply draw a light, off-center pencil line down your piece of paper. Cut some shapes and stick them to one side of your pencil line. Stick the offcuts on the other side of the line. Start with simple shapes, building up to more elaborate ones. Don't think about it too much—this is just quick and fun, but you will be amazed at the results.

LAYERING

Building up layers is an important part of some types of collage, bringing together different images **so that one is visible through another.** The technique makes for an intriguing piece of artwork and there are a number of ways in which to achieve it. Layering gives you the opportunity to **experiment with new techniques**. Along the way you may discover a whole new way of working and creating. You never know quite how the finished collage will turn out, but that's the joy of it. Sometimes it is all about happy accidents!

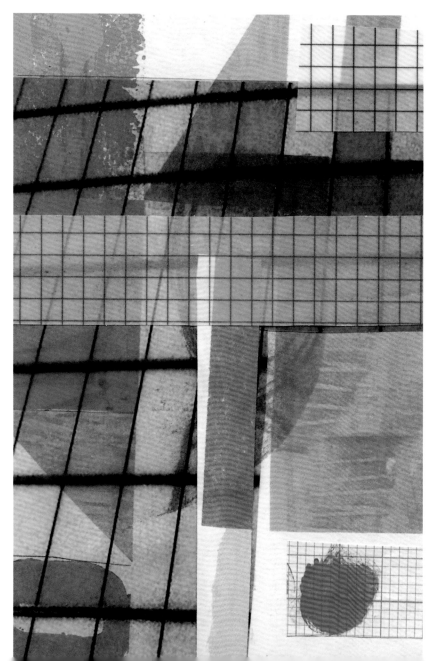

BASIC LAYERING

Gather together a few pieces of paper and images you want to use. Make a base layer. I love to use graph and lined paper as a background. It is neutral enough to let other imagery stand out from it, but also interesting in its own right. I also use pages from old books, music scores, faded maps, old letters, and ledgers. Tissue paper is also great for layering; overlap different colors and new colors are made. You can lay a base layer in cut sections or torn sections, or a mixture of both. Now add some areas of imagery or color. As you stick these pieces, before the layer is completely dry, tear off small sections, to reveal the layer beneath. Finally, add a top layer with something that is translucent. I print onto tracing paper or matte film for this layer.

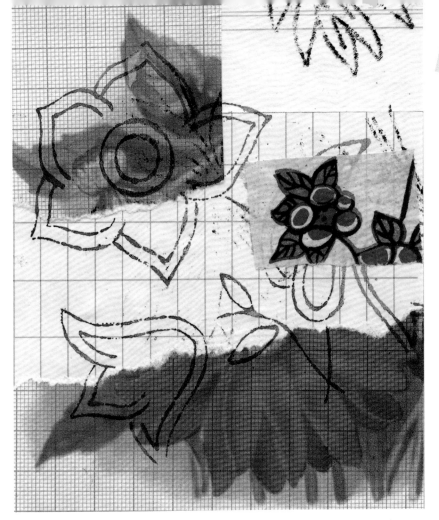

PHOTOCOPYING, TRANSFERRING, AND STAMPING

A printer or photocopier is a great tool for layering collages. You can really play around with scale. A small piece of hand lettering from an old postcard can be enlarged and printed onto tracing paper, to great effect. I also keep a lookout for vintage embroidery transfers. These can be ironed onto a collage. You can also use the method of transferring an image with a layer of medium (See Photo Montage, pages 84–86). Use rubber stamps to add an interesting layer. If you use slightly translucent ink, you will be able to see the layer beneath showing through in places.

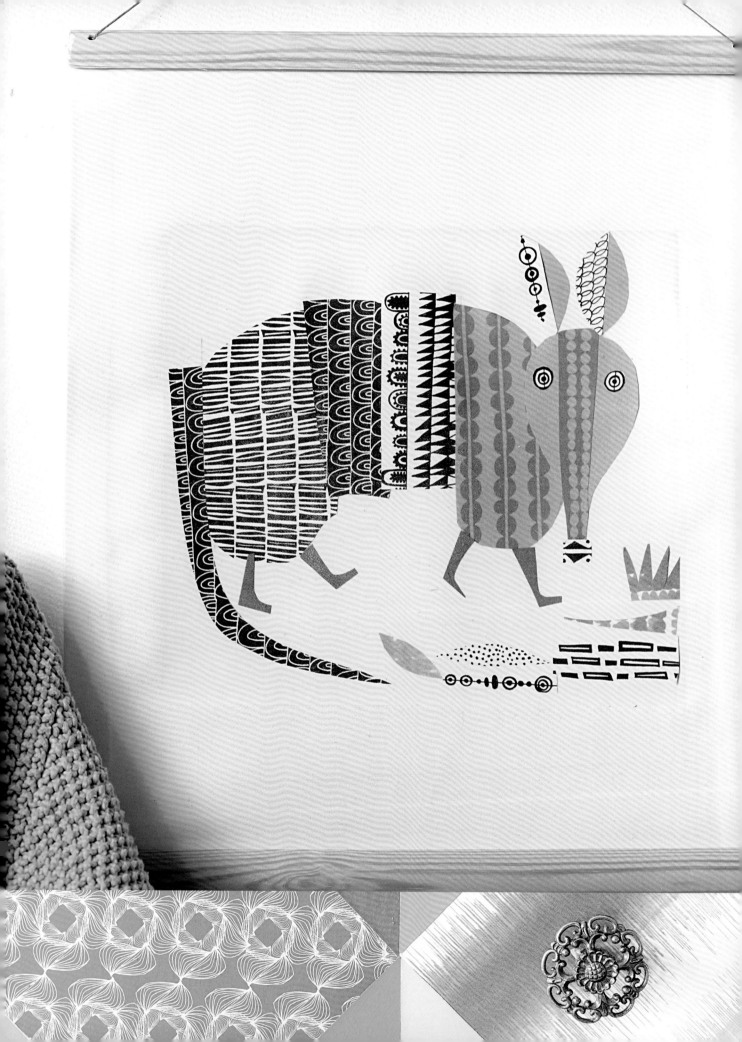

COLLAGE
PROJECTS

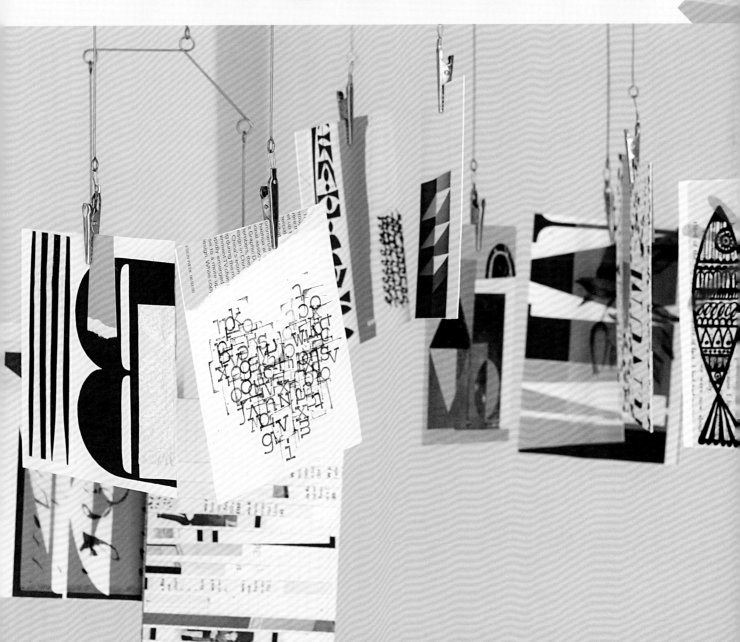

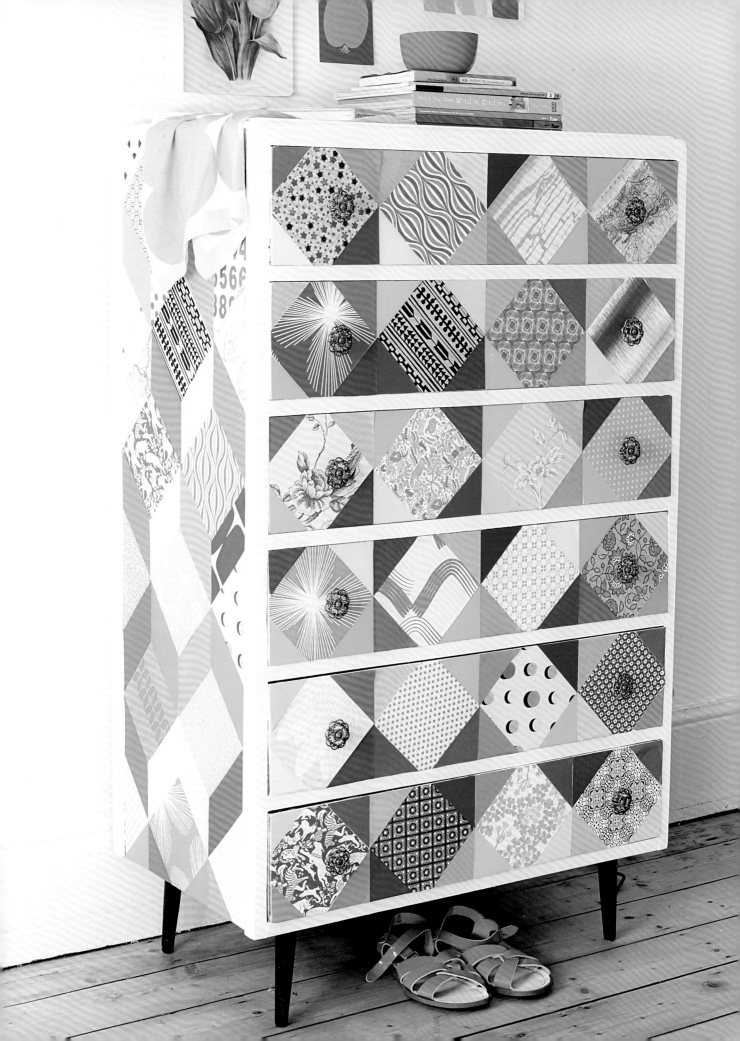

COLLAGE
A CABINET

I'm a fan of **large-scale collage** and I love **geometric patterns**. In this project, I have combined the two to give new life to an old chest of drawers. You can use anything to create the shapes—remnants of wallpaper, pages from magazines, old maps, or recycled giftwrap. I have included some panels of plain color, which helps to emphasize the **3-D effect** of the pattern.

▼ YOU WILL NEED

- ○ Templates, page 127
- ○ Tracing paper
- ○ Masking tape
- ○ Pencil
- ○ Ruler
- ○ Thin card stock (card)
- ○ Craft knife
- ○ Cutting mat
- ○ Selection of patterned and colored papers
- ○ Wallpaper glue

1 Trace out the templates, transfer the shapes to some thin card stock (card), and cut them out. Use a craft knife and ruler, and protect your work surface with a cutting mat.

2 Use the templates to cut shapes from your selection of papers. For each top section of a shape, you will need two side sections—a left and a right. I used patterned paper for the top shape, and plain paper for the side sections.

3 Use wallpaper glue to stick the first row of the pattern in place. This is made of squares turned to make a diamond—align one corner of each square with the top of the chest. Use a craft knife to trim any edges that overlap the edge of the chest.

4 Now stick the next row of the pattern in place. Continue adding rows in the same way until you have completed the design.

5 I chose a different design for the cabinet front, using four squares per drawer, turned to make diamonds and framed with small triangles. Your design will depend on the shape and size of the drawers. Unscrew any handles before covering the drawers and replace them when you have finished.

GET CREATIVE

Make up a different grid pattern for variation. You could keep it simple, with a patchwork of squares or triangles. If you want something a little more complicated, work out a repeat pattern on graph paper and then enlarge each of the different shapes to make up the templates.

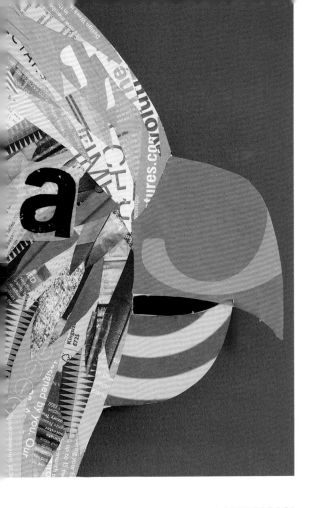

COLORFUL COCKATOO WALL ART

Make a **creative statement** with a piece of tropical wall art. I have called my collage a cockatoo, but cockatoos are not really these colors. Really, it's a mix-up bird and you can make it in any color you like. I have used **pages torn from old magazines**, organizing them into color groups. Cut out the shape and get sticking!

▼ YOU WILL NEED

○ Template, page 120

○ Pencil

○ Ruler

○ Sheet of foam board

○ Craft knife

○ Cutting mat

○ Pages torn from old magazines

○ Scissors

○ Paintbrush

○ PVA glue

✿ For this project, it is a good idea to place the PVA glue in a small bowl and mix it with some water. This will thin the glue down a little, making it easier to use. It will also dry faster.

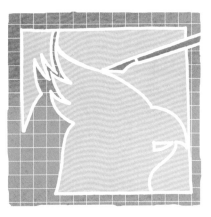

1 Use the grid method to enlarge the template onto the sheet of foam board (see Enlarging a Template, page 118). Cut out the shape using a craft knife and protecting your work surface with a cutting mat.

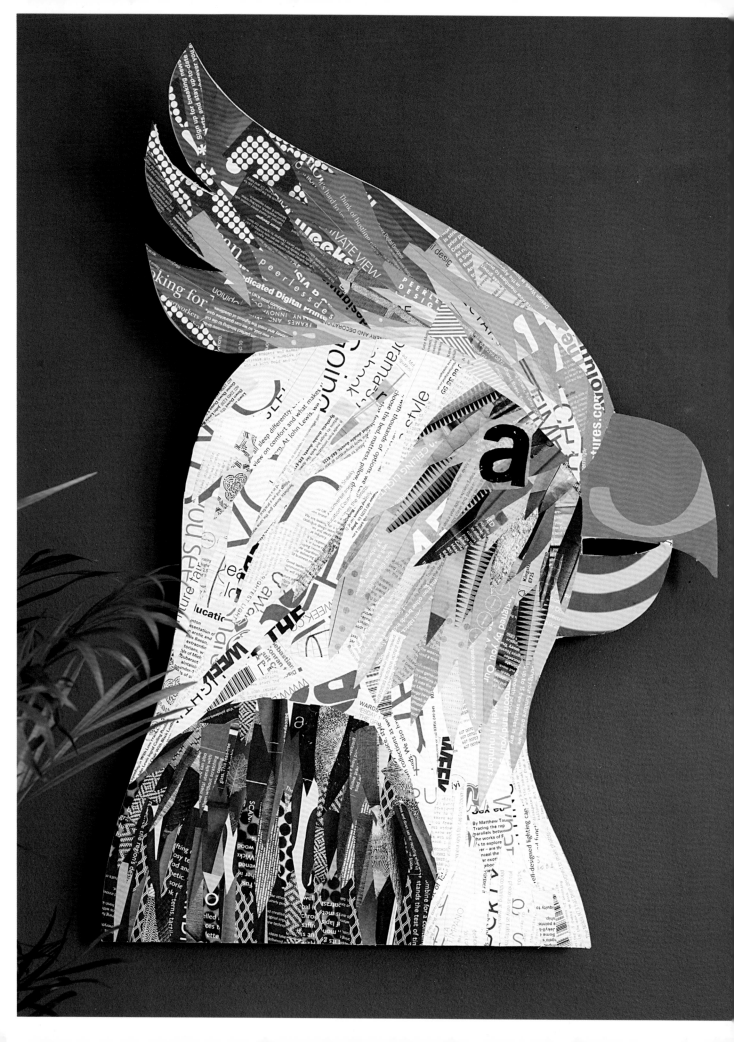

2 Use scissors to cut out a pile of elongated triangle shapes from the magazine pages. Stick them in place on the foam board using PVA glue and a paintbrush. For the crest of the bird, I stuck the triangle shapes pointing upward. For the head, I preferred them pointing down.

3 Cut out some shapes for the bird's beak and its eye. Stick the shapes in place.

4 Cut eight pieces of foam board measuring 2 in. (5 cm) square and make two stacks of four squares, sticking one on top of the next.

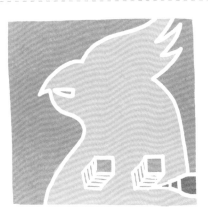

5 Stick the foam-board stacks to the back of your bird shape—they will project the artwork out from the wall. Center them, a little spaced apart and level with each other.

✿ The artwork is so light that sticky tack will hold it on the wall. If you prefer something more permanent, bang a couple nails into the wall, each one corresponding to one of the foam-board stacks for position. Press the foam board onto the nails.

GET CREATIVE

You can create any creature you like using this technique. Experiment with drawing simple animal shapes, before picking one to enlarge and collage in the same way. If you don't feel your drawing skills are up to it, the internet is full of royalty-free animal shapes (see page 128).

FRAMED LAYERS

A key element of collage is **building layers** (see Layering, page 26). For these pretty, botanical-style collages, I combined a selection of old prints, lovely typography from a magazine, and vintage embroidery transfers. Some of the imagery is printed onto tracing paper, allowing you to see through to different layers. Adding to this **idea of transparency**, I have used glass frames to mount my collages. It is a simple, but attractive, way to display a group of artworks.

▼ **YOU WILL NEED**

○ Selection of papers, prints, and transfers

○ Glue stick

○ The glass from a number of clip frames, two pieces per collage

○ Picture hooks, two per frame

○ Superglue

○ Washi tape

○ Scissors

○ Thin ribbon

1 Assemble your collages following the steps for layering (see page 26). Make sure the finished works are smaller than your pieces of glass.

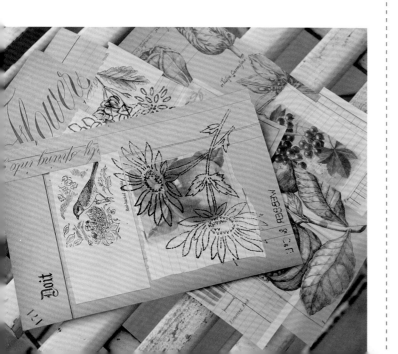

2 Following the manufacturer's instructions for the superglue, stick two picture hooks along the top edge of a piece of glass. Space them evenly, a little way in from each corner.

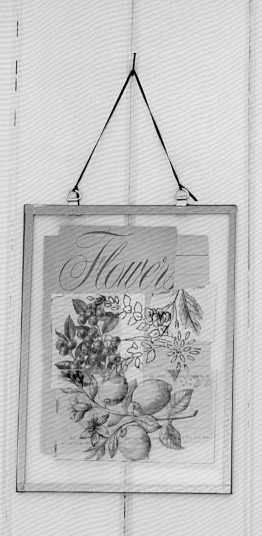

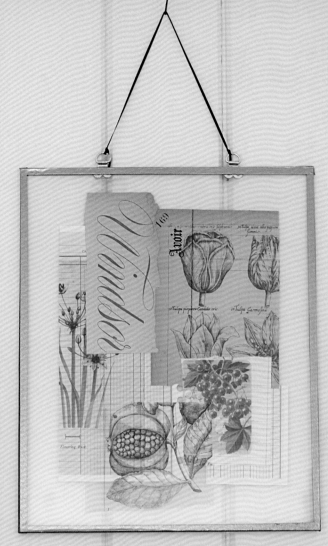

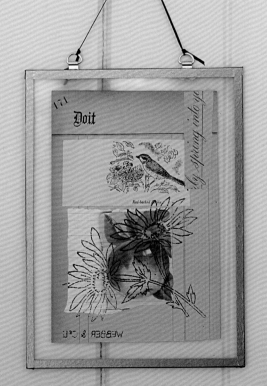

✿ Be very careful when using superglue. When checking to see if it is dry, avoid testing it with your fingers, but give it a prod with a toothpick, or similar.

✿ When sticking washi tape along the top section of the frame, cut the tape around the clips—snipping as close to the clips as you can—for a neater finish.

3 When the glue is dry, position your collage on the glass. You may want to give it a dab of glue stick to keep it in position.

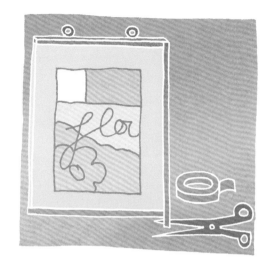

4 Place the second piece of glass on top of the first, and stick washi tape around the edges— I chose a copper-colored tape to create the look of a metal frame. Try to make sure there is the same width of tape to the front and back of the frame (this comes with a bit of practice). Trim off any excess tape at the end.

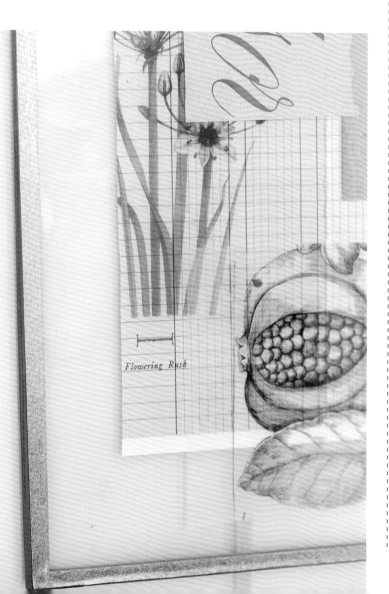

Flowering Rush

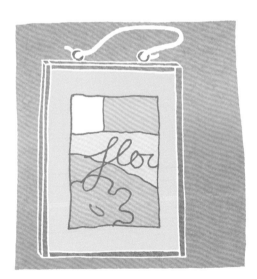

5 Tie a short length of thin ribbon to the picture hooks and your artwork is ready to hang.

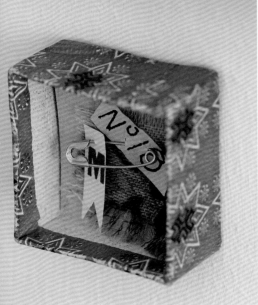
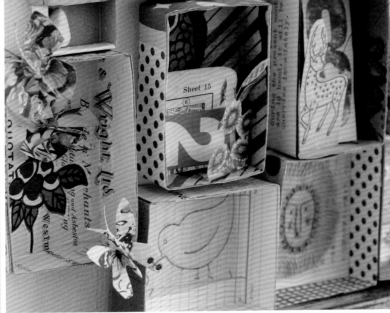

LITTLE BOXES

These little boxes are real fun to make. You simply take a number of plain cardboard boxes and cover, decorate, and fill them to create a **curious and intriguing collection**. You can use scraps of paper, bits of magazines, old photographs, and tiny objects. Group them together and display them as one piece—even when you have mounted them on the wall, you can **keep adding to the arrangement**.

1 Use the template to draw the shape on some card stock (card). I have provided one size, but you can make any size boxes you like.

▼ YOU WILL NEED

- Template, page 125
- Pencil
- Ruler
- Thin card stock (card), I used gray board
- Craft knife
- Cutting mat
- Blunt knife, or similar, for scoring
- PVA glue
- An assortment of papers for collaging
- Sticky tack

2 For each box, cut out the shape using a ruler and a craft knife. Protect your work surface with a cutting mat.

✿ For the boxes, you can use anything from matchboxes and small ready-made packaging to old sardine tins (taking care with any sharp edges).

3 Score the lines marked on the template using a ruler and a blunt knife.

GET CREATIVE

• You don't need a decorating theme, but here are some ideas: make a box to celebrate a birthday or anniversary and let the collection grow year by year; use bits and pieces collected from a vacation; make them for a friend or partner with little secret messages that only the two of you can work out.

4 Fold the flaps, dab them with glue, and stick them down to assemble the box.

• Think of ways in which to make a collage 3-D. Give a shape a tab, for instance, so that it stands proud when stuck inside the box. Or hang an object from a thread. You can also use 3-D objects—pebbles or shells, for example.

5 The box is now ready to decorate—I start by covering the inside and the outside edges with paper. When it comes to mounting the boxes on the wall, they are light enough that they can be secured using sticky tack.

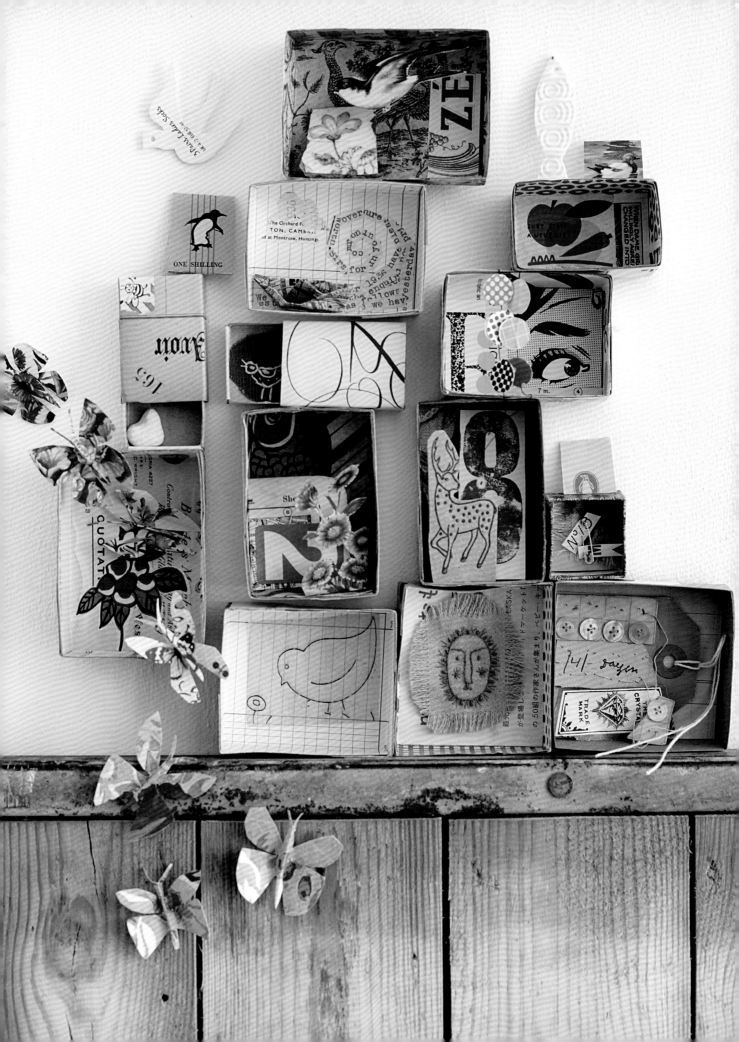

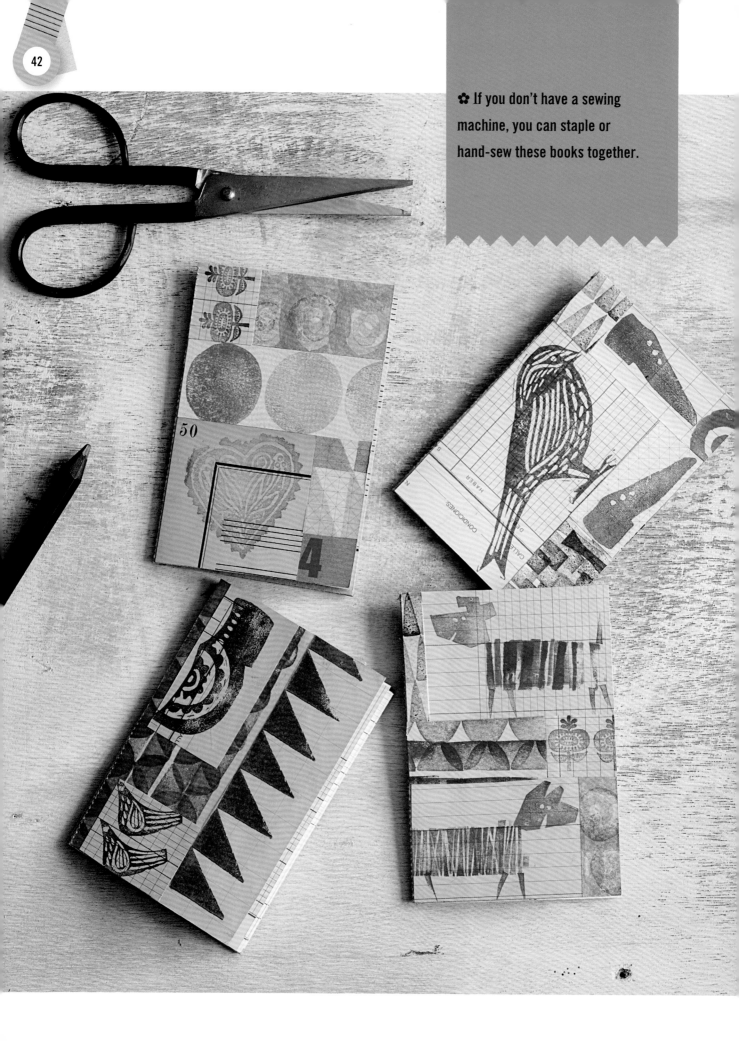

❀ If you don't have a sewing machine, you can staple or hand-sew these books together.

LITTLE NOTEBOOKS

You can **collage on the go** with this project—all you need is a glue stick, a small pair of scissors, and a mini notebook! Mine even has a pocket at the back for storing all the paper scraps I collect. My collage uses **hand-printed papers** (see Decorative Papers, page 13) and I have filled the notebooks with **graph paper and old music scores**. I am rarely without a small notebook in my bag. You never know when the creative bug will bite!

1 Transfer the template to some card stock (card) and cut it out. Use a craft knife and protect your work surface with a cutting mat.

2 Use a blunt knife to score along the lines marked on the template. Bend back the flaps, and dab them with glue. Stick the flaps to the back inside cover of the notebook to form a little pocket.

▼ YOU WILL NEED

- ○ Template, page 119
- ○ Tracing paper
- ○ Masking tape
- ○ Pencil
- ○ Ruler
- ○ Thin gray card stock (card)
- ○ Craft knife
- ○ Cutting mat
- ○ Blunt knife, or similar, for scoring
- ○ Glue stick
- ○ Hand-printed paper
- ○ Pages from old music or graph books
- ○ Sewing machine (optional)

3 Score the centerfold of the card and fold in half.

4 Decorate the front cover with a collage of hand-printed paper scraps.

5 Cut rectangles of graph or music paper measuring 7 x 5 in. (18 x 13 cm) and fold them in half to make the book pages.

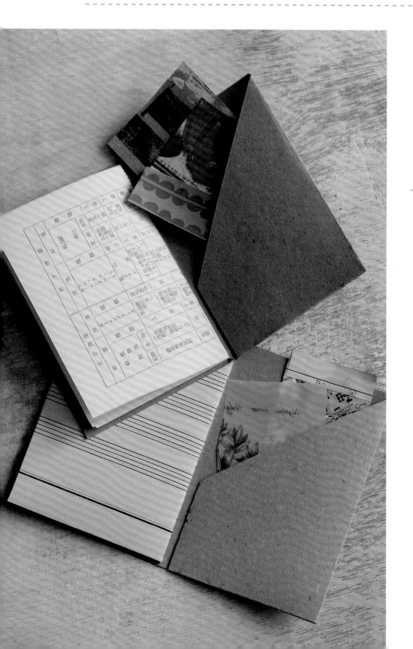

6 Position the pages within the cover, aligning the folds together. Run some stitching down the centerfold to complete the book.

PHOTO WALL HANGING

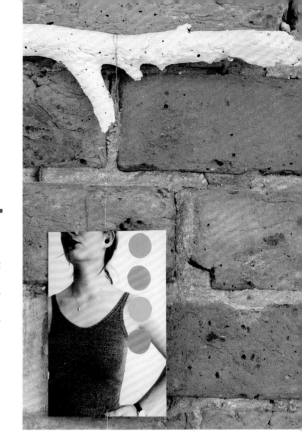

How many **photos** do you have stored on your camera and computer—hundreds or even thousands? I printed some of mine out in **black and white**, boosting up the contrast for extra drama. I then used semitranslucent colored tracing paper to collage some **abstract shapes** over the images and made this simple, but striking, photo display.

▼ **YOU WILL NEED**

○ Black-and-white photographs

○ Thin card stock (card)

○ Glue stick

○ Triangle (set square)

○ Pencil

○ Ruler

○ Craft knife

○ Cutting mat

○ Tracing paper

○ Color markers

○ Scissors

○ Hole punch

○ Thin wire

○ Wire cutters

○ Small pair of pliers

○ Length of driftwood measuring 27½ in. (70 cm)

○ White paint (optional)

○ Paintbrush (optional)

1 Stick some photos onto thin card stock (card) using a glue stick. When the glue is dry, use a triangle (set square), a pencil, and a ruler to crop the images. Mine are different sizes: The smallest measures $3\frac{1}{2}$ x $4\frac{3}{4}$ in. (9 x 12 cm) and the largest is 4 x $5\frac{1}{2}$ in. (10 x 14 cm). Use a craft knife to cut out your shapes and protect your work surface with a cutting mat.

2 Color up some tracing paper with flat areas of color. Use wide-tipped color markers to get an even coverage. Cut out some shapes to stick over the top of the photos—triangles, dots, stripes—anything goes.

3 Lay the finished photos in rows, changing them around until you are happy with the arrangement. Punch holes a few millimeters in from the top and bottom edges and centered between the side edges of each photo. (Photos in the bottom row only need holes at the top.)

4 Cut lengths of wire measuring 2¾ in. (7 cm). Leaving the topmost holes in the top row of photos free, use the wires to join the rows of photos together, so that the bottom of one photo is wired to the top of the one below it, as shown. Use pliers to manipulate the wire and trim off any excess.

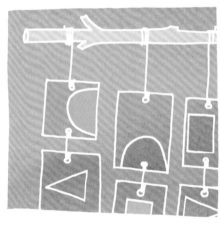

5 For the topmost holes in the top row, use lengths of wire measuring 12 in. (31 cm) to join the photo to the length of driftwood—I painted mine white. Space the rows of photos out evenly along the length of the wood and wind the wires around the stick to secure.

✿ When choosing shapes to stick on the photos, I look at the each image for inspiration, or I pick a specific area for emphasis.

✿ You can hang the wall hanging by banging two nails into the wall and hooking the branch over the top of them.

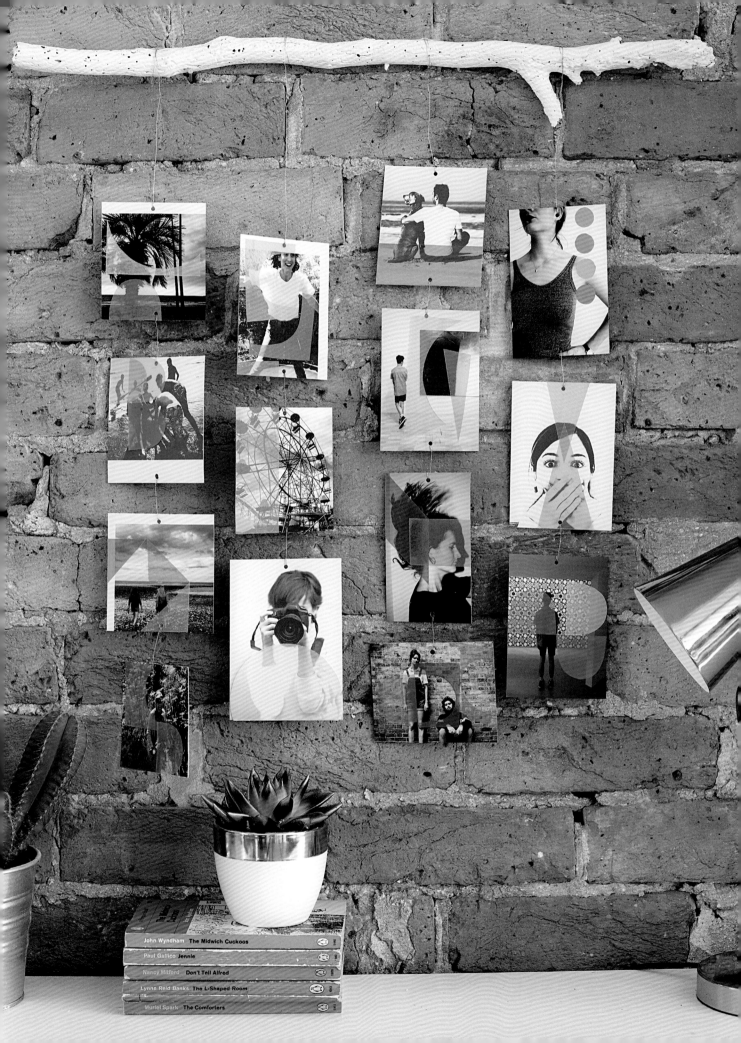

John Wyndham The Midwich Cuckoos

Paul Gallico Jennie

Nancy Mitford Don't Tell Alfred

Lynne Reid Banks The L-Shaped Room

Muriel Spark The Comforters

TEXTURAL BIRD

A rough piece of **salvaged wood** makes a great surface to work on. For this bird design, I **printed tissue paper** with different patterns, cut out various shapes, and stuck them down. Don't worry about being too neat—when using tissue paper and overlapping edges, nice **textured layers** develop. You can use the template for the bird or design your own image, but keep the shapes simple. A fish would work well, or simple stripes of patterned paper to make an abstract design.

▼ **YOU WILL NEED**

- ○ Template, page 120
- ○ Scissors
- ○ Wooden panel
- ○ Pencil
- ○ Rubber stamps
- ○ Ink-stamping pad
- ○ Tissue paper
- ○ PVA glue
- ○ Small paintbrush

1 Enlarge the template and use scissors to cut it out (see Enlarging a Template, page 118).

2 Position the template on the wooden panel and draw around it using pencil.

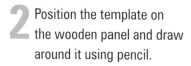

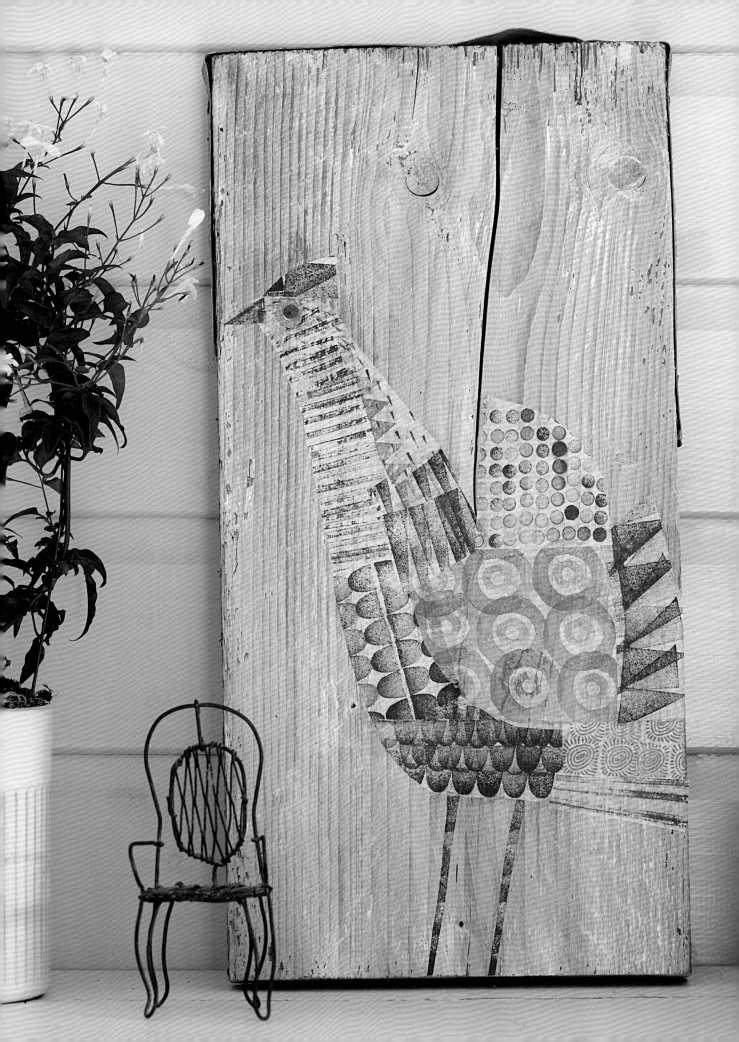

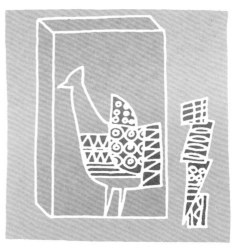

3 Use the rubber stamps to print patterns on the tissue paper. I used black ink on white tissue—the intensity of the pattern varies depending on how much ink is on the stamp, how hard you press, and whether or not you overlap.

4 Cut the printed tissue paper into sections and start playing around with the arrangement of them within the drawn-out bird shape.

✿ If your paper shapes overlap your original pencil edge, you can easily trim the paper back using a craft knife.

GET CREATIVE
Try your hand at making your own rubber stamps for this project. Cut simple shapes from an eraser, using a craft knife. For added texture, use a lino-cutting tool to cut, stripes, dots, or dashes into the surface of the rubber. (See also page 12.)

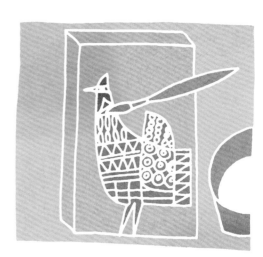

5 Dilute some PVA glue with water. Taking care not to disturb your arrangement too much, remove each section of tissue paper in turn, paste glue onto the surface of the wood, and stick the paper back in place. Press the tissue paper down gently so that it bonds well with the wood.

TRAVEL JOURNAL

When I was a child, my family traveled every summer, and my parents gave me a notebook to use as a journal and sketchbook. I used to stick in things of interest that I collected along the way. A travel journal is a lovely way to **record a journey** and hold onto **happy memories**. This would make a lovely gift for a friend who is about to embark on a trip. I have collaged the front cover in **travel-related ephemera** that I have collected, but you can download suitable images, too. (See Downloading Royalty-free Images, page 20).

▼ YOU WILL NEED

- ○ 3 pieces of card stock (card) measuring 8 x 8 in. (20 x 20 cm)
- ○ Pencil
- ○ Ruler
- ○ Craft knife
- ○ Cutting mat
- ○ A stack of graph paper measuring 8 x 8 in. (20 x 20 cm)
- ○ Travel-related ephemera— postcards, stamps, maps (see Collecting Ephemera, page 18)
- ○ Scissors
- ○ Glue stick
- ○ Blunt-knife, or similar, for scoring
- ○ Template, page 123
- ○ Tracing paper
- ○ Masking tape
- ○ $\frac{2}{3}$-in. (15-mm) wide elastic, measuring 11 in. (28 cm)
- ○ Sewing machine or needle and thread

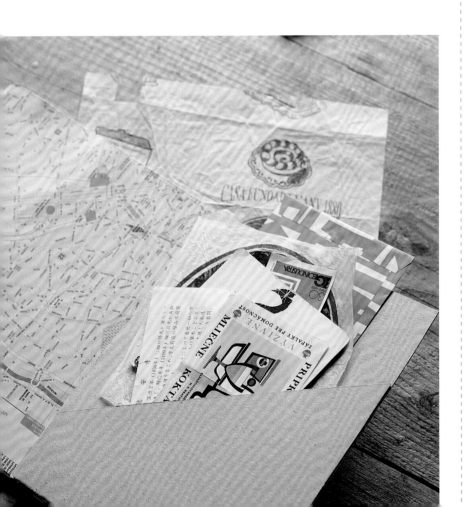

1 Take two pieces of card stock (card). At both the top and bottom of each piece of card stock (card), and $\frac{3}{4}$ in. (2 cm) in from the outside edge, cut a rectangle measuring $\frac{3}{4}$ x $\frac{2}{3}$ in. (2 x 1.8 cm) wide. Use a craft knife and protect your work surface with a cutting mat.

2 Repeat Step 1, to cut the same shape from the sheets of graph paper. Save time by cutting several sheets at a time.

3 Make a collage on the front piece of card using the travel ephemera. Work just up to the indented section and use a blunt knife to score the edge of the indent. This will make it easier to turn back the cover.

4 Trace out the pocket template and transfer the shape onto the third piece of card stock (card). Cut the shape out.

5 Score along the lines marked on the pocket template and bend back the glue flaps. Glue the flaps and stick the pocket in position to the inside back cover of the journal. Align the side and bottom of the pocket as shown.

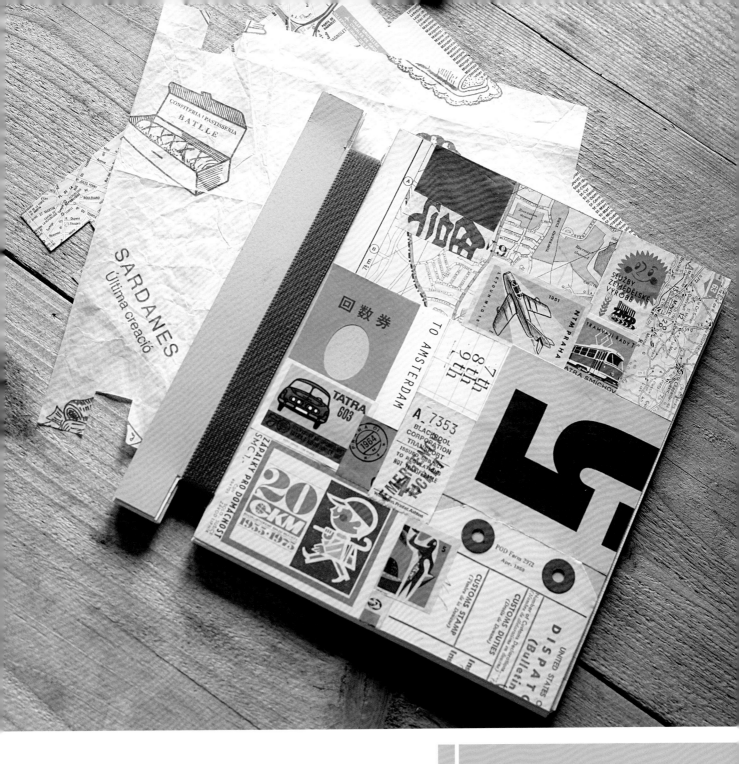

6 Form a loop with the elastic, sewing the ends where they overlap. I used a sewing machine but you could hand-sew it. Loop the band over the indented sections of the journal to complete.

GET CREATIVE

Adapt this project to create other journals. How about a recipe book? Cover the front with clippings from magazines, sections of old handwritten recipes, and interesting bits of packaging. It would make a lovely gift for a student off to university or a friend moving into his or her first home.

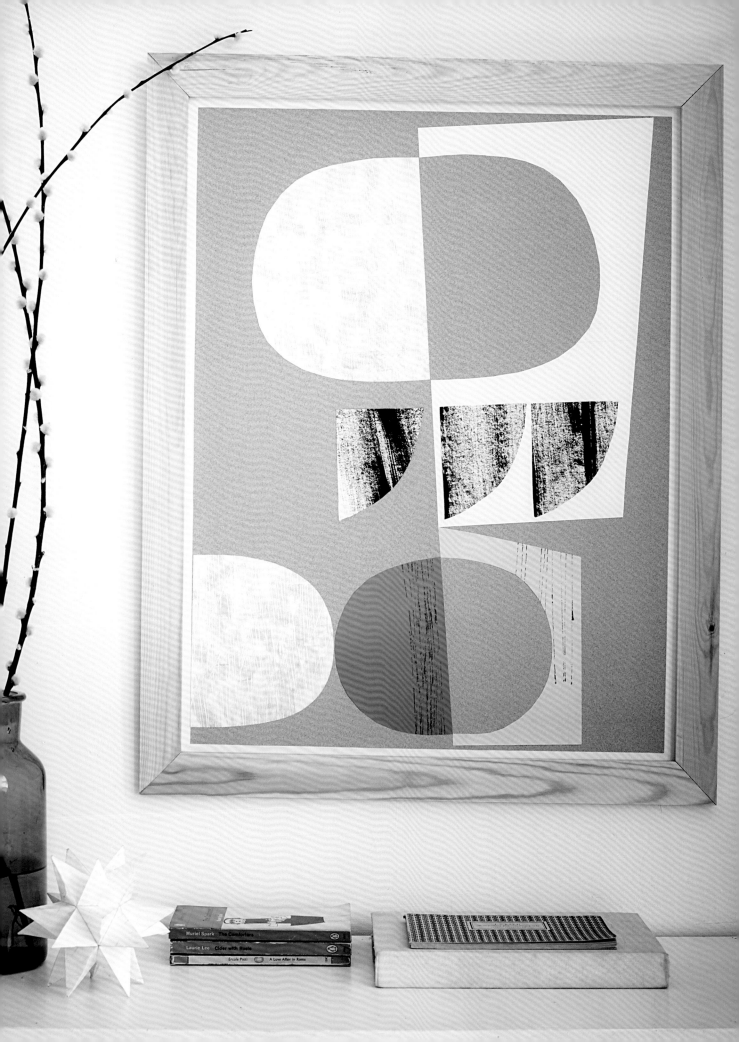

LARGE-SCALE ABSTRACT

Use **simple cutout shapes** to make a stunning piece of art. Simply choose a selection of colors you like and go for bold! One way to compose your design is by cutting shapes from newspaper and playing around with them. I like to make a series of small **postcard-sized collages** in my chosen colors and select one of these to enlarge. If you need help planning your design see Composition, page 21. For this project, I **added texture to the flat colors** and, to finish, I made a simple wooden frame.

▼ YOU WILL NEED

For the large-scale design

○ Ledger-size (A3) sheets of plain paper in your chosen colors, plus white

○ Black paint

○ Wide paintbrush

○ Strip of card stock (card) measuring 4 x 1¼ in. (10 x 3 cm)

○ Ink-stamping pads in black and gray

○ Small piece of lino

○ Lino-cutting tool

○ Scissors

○ PVA glue

○ Large sheet of paper measuring 25½ x 19¾ in. (65 x 50 cm)

○ Mounting board measuring 29½ x 23½ in. (75 x 60 cm)

For the postcards

○ Thin card stock (card) measuring 6 x 4¼ in. (15 x 11 cm)

○ Pieces of paper in your chosen colors

○ Scissors

○ PVA glue

For the frame

○ 1½ x ½ in. (4 x 1 cm) wooden batons: two measuring 30 in. (76 cm) in length and two measuring 12 in. (31 cm)

○ Small wood saw

○ Miter block

○ Wood glue

○ Triangle (set square)

○ Panel pins

○ Hammer

○ Staple gun

○ D-rings

○ Picture cord

1 Start by adding texture to your plain paper. Make some wide brushstrokes using black paint on a sheet of white paper.

2 Press the edge of the strip of card stock (card) into the black ink-stamping pad and use this to make some textural lines on colored paper.

3 Cut some lines into a small piece of lino. Mine measured 3 x 1½ in. (8 x 4 cm). Press the lino into the gray ink-stamping pad and print up some areas of color on your papers (see Decorative Papers, page 18).

4 Now make up some postcard-sized collages. Cut plain and textured paper into simple shapes and experiment with different compositions.

5 Choose the design you like most and cut pieces of paper that match the small ones in color but are larger in scale. They don't have to be exact—experiment with the shapes, as you may find you want to add more or introduce an additional color. Position the pieces on the large sheet of paper and play around with the arrangement. When you are happy with your design, stick the shapes down.

6 Stick the collage onto the mounting board, making sure there is an even border all around the collage.

7 To make the frame, cut the ends of the wooden batons to a 45-degree angle, preferably using a miter block, and remembering that the outer edge of the cut baton should be the longest.

8 Make up the frame, gluing each of the corners in turn. It is helpful to use a triangle (set square) to get good 90-degree angles. Carefully tap in a panel pin at each corner for added strength.

9 Lay the frame over the mounting card, making sure there is an even border all around and use a staple gun to attach the card to the frame.

GET CREATIVE

If you use postcard-sized collages to decide on a composition, these can make lovely artworks in their own right. Frame them in groups or turn them into greetings cards.

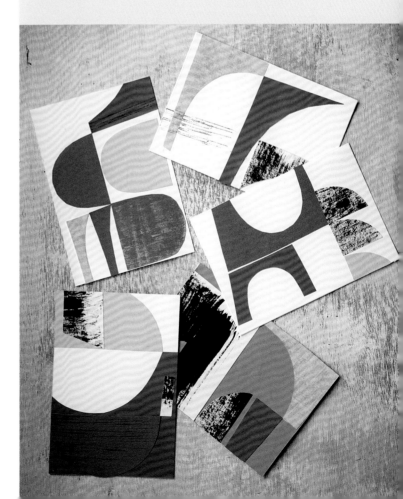

10 Add D-rings and cord for hanging the collage.

COLLAGED TOTE

I have been collecting printed paper for many years. I like anything from **bits of packaging** to **old postcards** and **envelopes**, and even the **odd bit of junk mail**, if it has an interesting design. These bits and pieces are stored away in files and boxes, which is a shame, as some pieces are really beautiful and deserve to be seen. For this project I have made collages using papers from my collection, sandwiched them between **clear polythene sheets**, and sewn them into a simple bag. It is strong, waterproof, and unique!

✿ It is a little tricky to sew plastic using a sewing machine, because the foot doesn't always grip. To get around this, place a piece of tracing paper between the foot and the plastic. You can tear it away once you have completed the line of stitching.

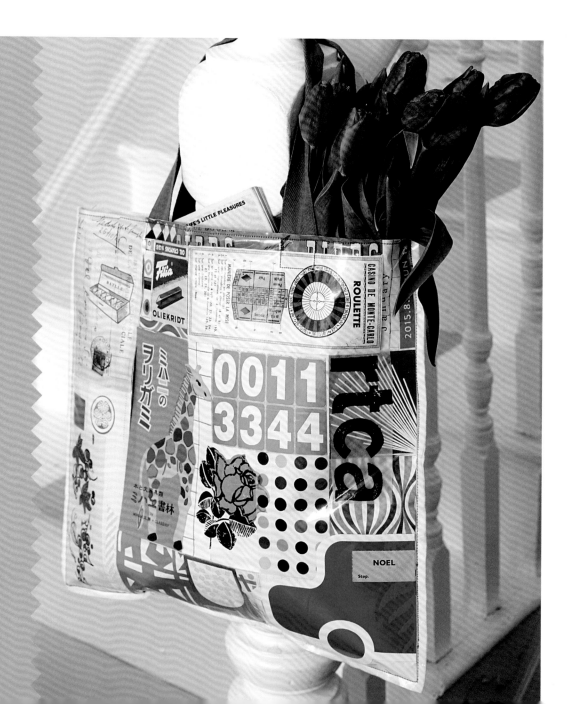

▼ YOU WILL NEED

- ○ Two sheets of paper measuring 16 x 14 in. (40 x 36 cm)
- ○ Collection of ephemera (see Collecting Ephemera, page 18)
- ○ Tracing paper (optional)
- ○ PVA glue
- ○ Paintbrush
- ○ 4 sheets of thick, clear polythene measuring 16 x 14 in. (40 x 36 cm)
- ○ Sewing machine
- ○ I yd (1 m) of 1½-in. (4-cm) wide cotton webbing
- ○ Pins
- ○ Masking tape (optional)

1 Make collages, using your collection of ephemera to cover the two sheets of paper. Print designs onto tracing paper to add more layers, if you like. Use PVA glue and a paintbrush to paste the pieces in place.

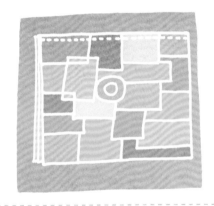

2 Sandwich the first collaged sheet between two sheets of polythene. Machine-sew a line of stitching ¼ in. (8 mm) along the top edge of the polythene, to join the three layers together. Repeat with the second collaged sheet.

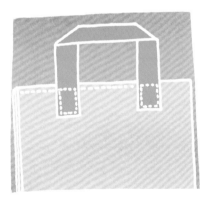

3 Cut the length of cotton webbing in half and use to make two handles. Place the ends of one handle 4¼ in. (11 cm) in from the side edges of the first collaged sheet, and 1½ in. (4 cm) down from the top. Pin into position or, if you don't want to make holes in the plastic, hold the handle in place using masking tape. Machine-sew a square of stitching to secure the handle on each side. Repeat this step to make the second handle.

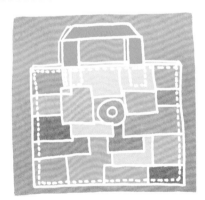

4 Place the two sides of the bag together, wrong sides facing. Machine-sew a straight line of stitching down each side and along the bottom, using tracing paper if need be (see opposite), to finish the bag.

LUGGAGE-LABEL
GIFT TAGS

I like to work on collections of **small collages based around the same theme**, and have found luggage labels to be the perfect size for trying out new ideas. For this project, I kept the same **monochrome color scheme** throughout. Although each collage is very different, the set works well together.

1 To make the typographical circular design, cut a small circle of colored paper and stick it on the luggage label. Cut thin strips from an area of text in a magazine.

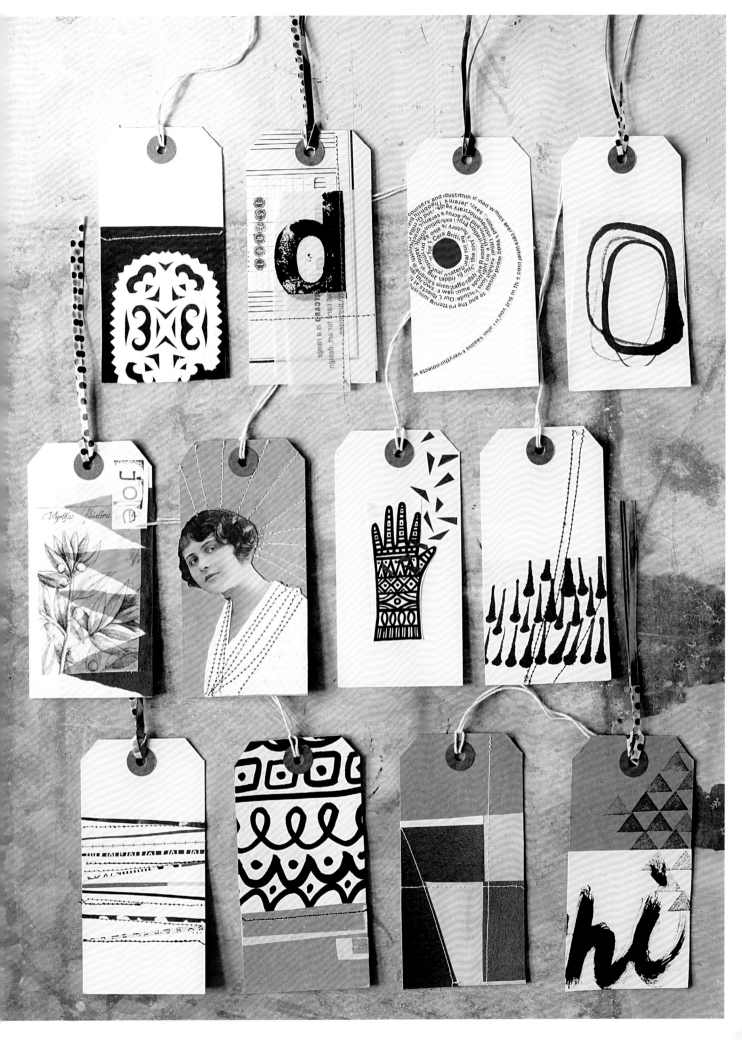

2 Cut the strips of magazine text into small segments and stick them around the circle to create a spiral effect around it.

3 To make the tag with horizontal lines, cut thin strips of colored and patterned paper and stick them across the card at different angles. Stitch some extra lines using a sewing machine, if you like. One of my chosen colors for this theme is bronze, so I have used metallic thread to match.

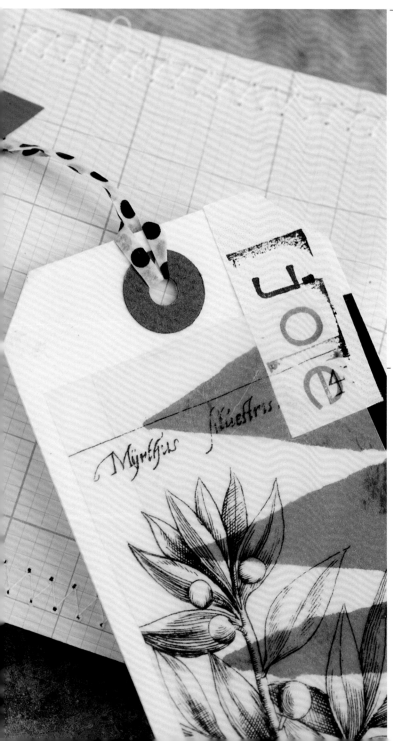

4 Old photos can be used to great effect. I cut a figure of a woman from an old postcard and replaced the shape of her blouse with graph paper. I stitched extra detail using a sewing machine.

5 For another tag, fold a small piece of oval-shaped paper into quarters. Cut a few small snips from the folded paper, as if making a paper snowflake.

6 Open up the folded paper and stick it to a dark paper background, to really show off the design.

7 Make more tags using simple collages made by layering printed tracing paper over patterned paper.

8 To finish the tags, I swopped some of the string ties for ones made from washi tape folded in half and cut into very thin strips.

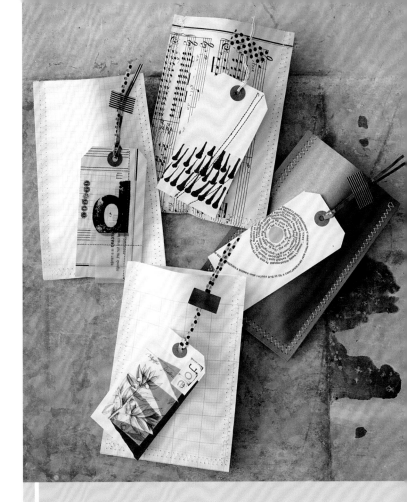

9 To make little paper gift bags, cut two pieces of paper measuring 7 x 4¾ in. (18 x 12 cm). Lay the two pieces of paper together and machine-sew along the bottom and two side edges using zigzag stitch.

GET CREATIVE

• Team gift tags with simple handmade paper bags to give your guests a small gift at the end of a stylish get together.

• Make gift tags and giftwrap for a kid's birthday present. A mix of brightly patterned paper and sections cut from comics work well.

• These tags look lovely as an art piece in their own right. Frame them grouped together in lines or tie them to a length of tape for a garland.

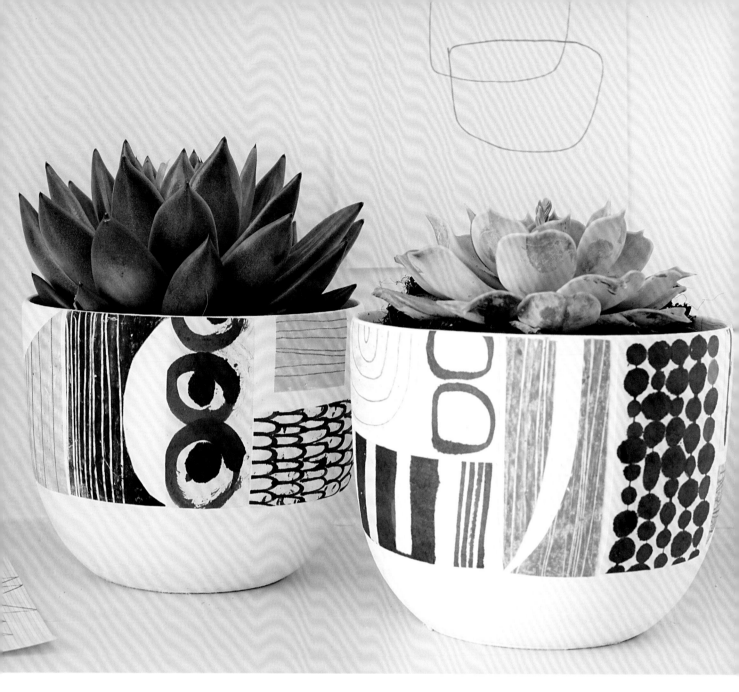

ABSTRACT POTS

You can apply the art of collage to anything— paper, fabric, and wood. I thought I would try **working with ceramic**, and was both surprised and pleased to see the results. I recently bought a stack of unprinted newsprint paper for experimenting with and it was ideal for this project. The paper is very thin, so adheres closely to the surface of the pot. I chose **abstract lines** and a pale color palette, mixed with black, to give my pots a contemporary and fresh appeal.

1 Give your pot a coat of matte white paint. Let dry and paint a second coat.

2 Cut some shapes from your selection of patterned papers and arrange them in a row to see how they might work together around the pot. I cut rectangles, semicircles, and triangles.

▼ YOU WILL NEED

- ○ Ceramic pot
- ○ Matte white paint
- ○ Paintbrush
- ○ Selection of patterns on thin paper (see Decorative Papers, page 13)
- ○ Scissors
- ○ PVA glue
- ○ Matte, water-based acrylic adhesive

3 When you are happy with the arrangement, use craft glue to stick the shapes to the pot.

4 Coat the pot with a couple of layers of matte acrylic adhesive to protect it from the odd splash of water.

WILDLIFE CUTOUTS

These little **cutout creatures** are simple to make. I used a mixture of my own patterned paper—made using brush and ink—over scraps of paper cut from magazines. Join a few together with string to make a charming hanging decoration, or mount them on sticks for a most **unusual and arresting display**.

▼ YOU WILL NEED

- ○ Templates, pages 126–127
- ○ Tracing paper
- ○ Masking tape
- ○ Pencil
- ○ Thin card stock (card)
- ○ Scissors
- ○ Scraps of paper
- ○ PVA glue
- ○ Ruler
- ○ Rotary hole punch
- ○ Wooden skewers
- ○ Small block of wood: mine measured 3¼ x 3¼ in. (8 x 8 cm)
- ○ Drill

1 To make the bird, trace out the templates for its body and wings and transfer them onto some thin card stock (card). Cut out the shapes using scissors.

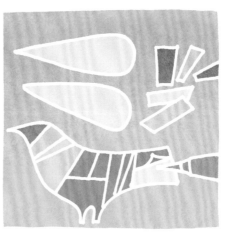

2 Cover the shapes in collage. I used black ink patterns and pops of bright color from magazine pages.

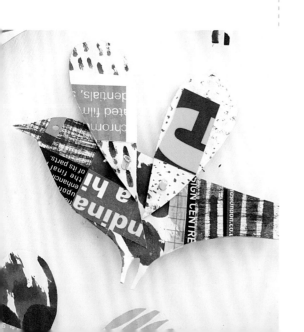

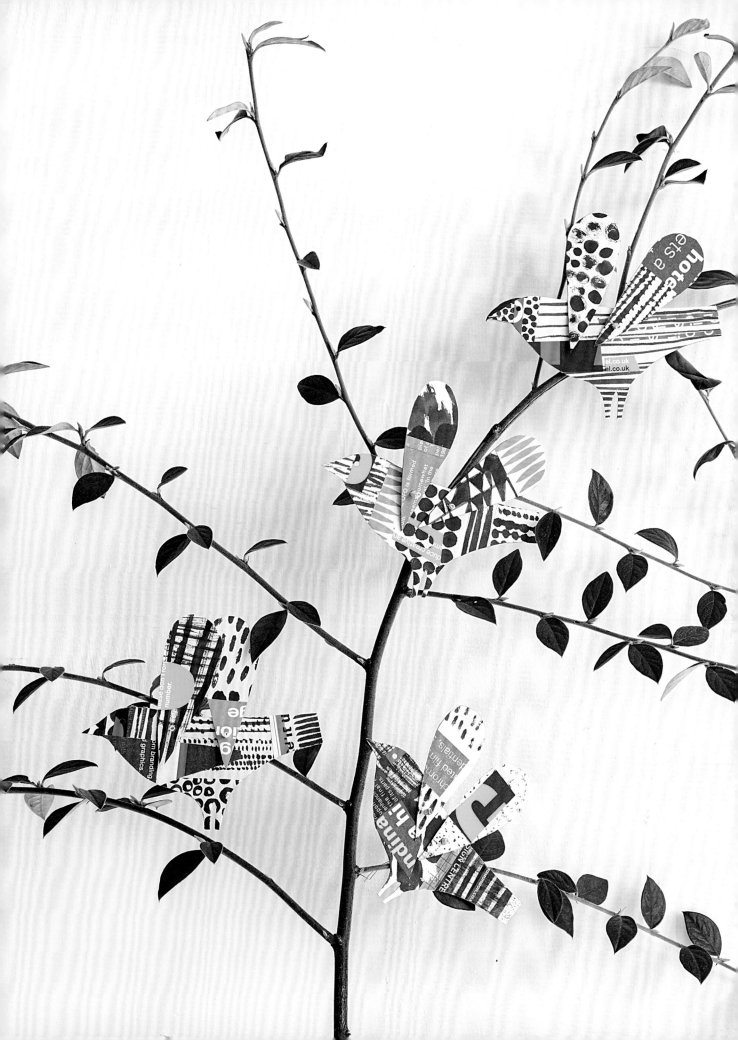

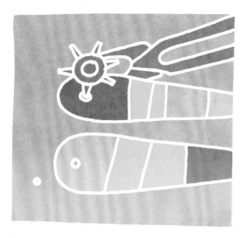

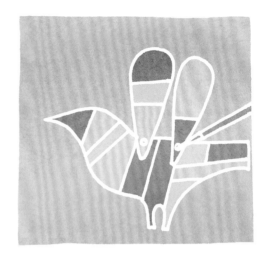

3 Using a 2 mm hole punch, make a hole in both of the wings, centered and ½ in. (1 cm) up from the bottom.

4 Position the wings on the bird and mark through the hole using a pencil. Punch a hole through the card at each of these two points.

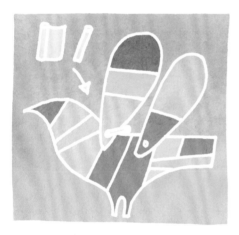

5 Cut a small rectangle of paper measuring 2 x ½ in. (5 x 1 cm). Roll this up tightly, from the short end, to make a peg. It needs to fit snugly through both the hole in the wing and the body of the bird—you'll probably need to experiment. Repeat with the second wing. Now you can move the wings into different positions.

6 Punch a hole to make the eye.

7 **To make the owl**, repeat Steps 1 to 6, sticking the head to the body and marking a single hole for the wings.

✿ If you want to mount two creatures in the same block, trim one of the wooden skewers, so that the animals are displayed at different heights. If you are drilling two holes, drill one toward the back of the block and one toward the front.

8 **To make the tiger**, repeat Steps 1 to 6, sticking the head to the body and marking holes for the legs.

9 To mount a cutout creature, run some PVA glue down the back of the animal's body and place the end of the wooden skewer on the glue. Let dry.

10 Drill a 1¼-in. (3-cm) deep hole in the wooden block, to slot the skewer into.

BRIGHT ABSTRACT PILLOW

▼ YOU WILL NEED

- ○ 2 letter-size (A4) sheets of white paper
- ○ Tissue paper
- ○ Painted paper
- ○ Scissors
- ○ Glue stick
- ○ 2 letter-size (A4) sheets of photo transfer paper for pale-colored T-shirts
- ○ I piece of ironed, white cotton fabric measuring $34\frac{1}{4}$ x $15\frac{3}{4}$ in. (87 x 40 cm)
- ○ Iron
- ○ Pins
- ○ Sewing machine

Turn a collage into a pillow! For this project, I used **brightly colored tissue paper** in combination with sections of **painted paper** to create a gorgeous contemporary and colorful pillow cover. Photo transfer paper comes in packs of 10, so you could fill a couch with your own beautiful creations. The instructions that follow make a cover for a 16 x 16 in. (41 x 41 cm) pillow form.

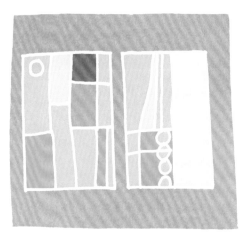

1 Fill one sheet of white paper completely with collage. On the other sheet of white paper, fill an area that is the length of the paper and 4 in. (10 cm) wide. You are going to join the two collage sections together to make one design, so consider how the two pieces will look side by side.

2 Follow the instructions for the photo transfer paper to copy the collages onto the correct side of the paper.

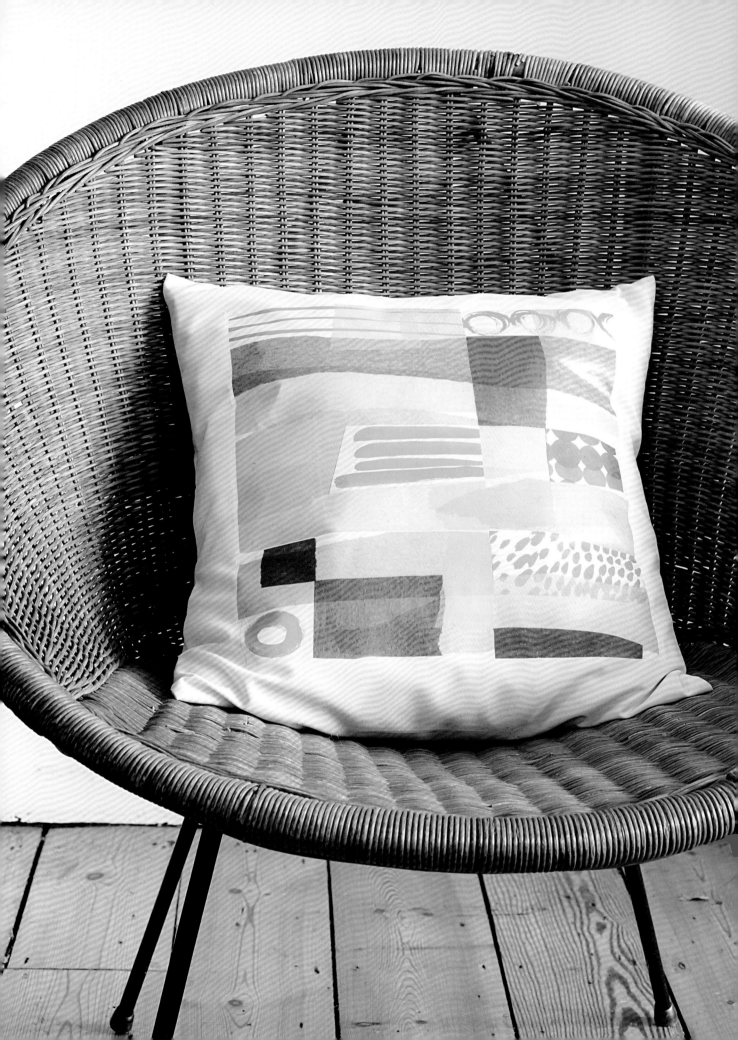

3 Trim the excess photo transfer paper from the smaller collage and follow the instructions for ironing the collage onto the fabric. Butt the two collage pieces up against each other 11 in. (28 cm) in from the top edge of the fabric and centered between the side edges.

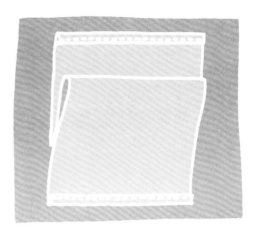

4 Once you have removed the backing paper from the photo transfer paper and the collage has successfully transferred onto the fabric, turn over a double $\frac{1}{2}$ in. (1 cm) hem along each short edge. Pin and machine-sew a line of stitching.

5 With the collage closer to the top edge, lay the length of fabric on a flat surface, right side up. Fold the top edge of the fabric over toward the center, making the fold 2 in. (5 cm) from the start of the collage. Fold the bottom edge over in the same way so that it overlaps the top edge, as shown. Pin in place.

6 Machine-sew each side of the fabric, taking a $\frac{1}{2}$ in. (1 cm) seam. Turn the pillow cover the right way out and press the edges for a nice crisp finish, taking care not to run the iron over the collage transfer.

FISHY PLACE MAT

I used lovely scraps of **oil-pastel-textured paper**, alongside **graph paper** and some **paper-cut leaves** to make this fish-themed collage. I turned it into a place mat using a **photo transfer sheet** and white fabric. It may not withstand a dish straight from the oven, but it will protect your table from watermarks and scratches. It looks great, too! Any collage you make will work for this project, but keep it letter size (A4) to fit the photo transfer paper.

▼ **YOU WILL NEED**

○ Letter-size (A4) collage

○ Letter-size (A4) sheet of photo transfer paper for pale-colored T-shirts

○ 2 pieces of ironed, white fabric measuring 11½ x 15 in. (29 x 38 cm)

○ Iron

○ Thin cotton batting (wadding) measuring 11½ x 15 in. (29 x 38 cm)

○ Sewing machine

○ Scissors

○ Sewing needle and thread

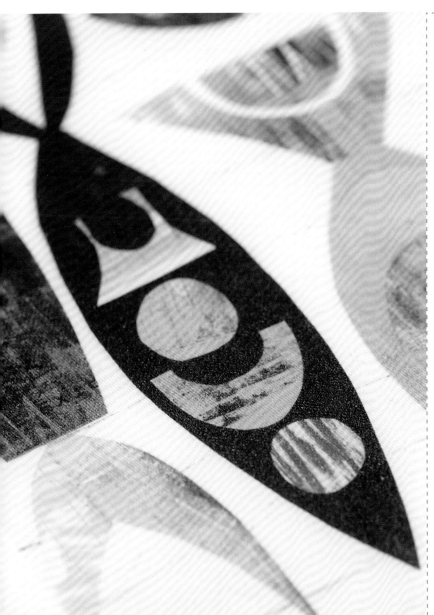

1 Follow the instructions for the photo transfer paper to print the collage onto the correct side of the letter-size (A4) paper.

2 Center the photo transfer paper on one piece of fabric and follow the instructions to iron-transfer the image.

3 Once you have peeled off the photo transfer backing paper, lay the fabric with the collage design face up on your work surface. Lay the second piece of fabric over the top and the cotton batting (wadding) over the top of that. Make sure all corners are neatly aligned.

4 Use a sewing machine to make a ½ in. (1 cm) line of stitching around all the sides and through all the layers, and leaving a 6 in. (15 cm) gap in one of the sides.

5 Trim the seams back to ¼ in. (5 mm) and snip across each of the four corners, taking care not to cut into the stitching.

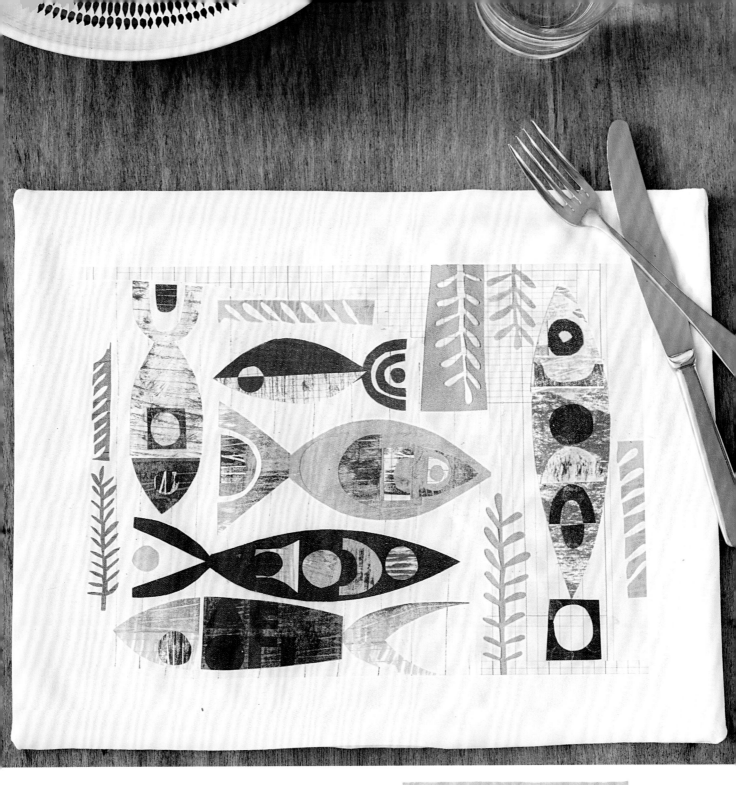

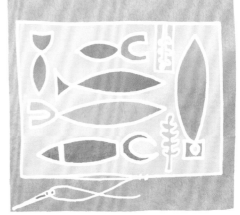

6 Turn the piece right side out. Close the gap, making small stitches with a sewing needle and thread. Press the edges of the piece, taking care to keep the hot iron away from the transfer.

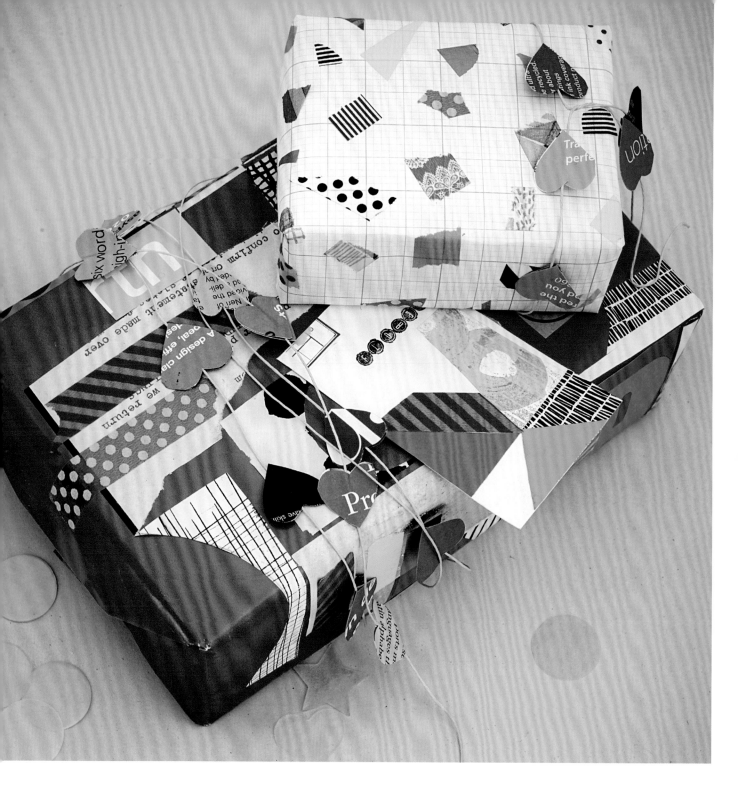

GIFTWRAP

I save all my scraps of paper and find it difficult to throw even the smallest pieces away. If you are the same, one way of putting them to good use is by making your own giftwrap. I used a **plain, brightly colored sheet** of paper as a background for one piece of giftwrap and some **graph paper** for the other piece—**anything goes**. I also made a **gift tag** and a string of collaged hearts.

▼ YOU WILL NEED

- ○ Scraps of colored paper
- ○ Large sheet of background paper
- ○ Glue stick
- ○ Scissors
- ○ String or twine
- ○ Thin card stock (card)

1 Position scraps of paper on the large sheet of background paper. Push them around until you are happy with the arrangement. Stick them down in position.

GET CREATIVE

Personalize a sheet of giftwrap for a friend by adding photos and words cut from magazines. You could make typography the star of the design. Find letters in different sizes and fonts to spell their name, and find numbers for celebration dates. Alphabet rubber stamps, from craft suppliers, are great for this. Mix up sizes and colors to add to the party vibes!

2 To make a string of hearts, cut a heart shape from a piece of paper and use this as a template to cut out a good number of them.

3 Cut a length of string. Dab glue to the wrong side of a heart. Place another heart over the top, right side up, sandwiching the string between the two. Repeat to add more hearts, spaced evenly, down the length of the string. You could make stars or triangles as a variation.

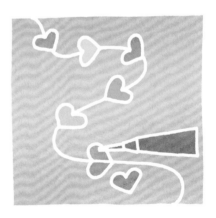

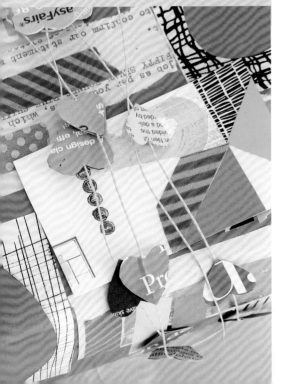

4 To make the tag, cut a rectangle of thin card stock (card) and decorate it with a collage. I have added a name to mine, using some alphabet stamps.

ARMADILLO FABRIC WALL HANGING

▼ YOU WILL NEED

- ○ Template, page 119
- ○ Tracing paper
- ○ Pencil
- ○ Masking tape
- ○ Letter-size (A4) sheet of paper
- ○ Patterned papers
- ○ Scissors
- ○ Glue stick
- ○ Letter-size (A4) sheet of photo transfer paper for pale-colored T-shirts
- ○ Piece of white fabric measuring 13¾ x 13¾ in. (35 x 35 cm)
- ○ Iron
- ○ Iron-on hemming tape
- ○ 2 lengths of wooden baton measuring 12 in. (31 cm)
- ○ Drill
- ○ String
- ○ Wood glue

Making a wall hanging is a fantastic way to display a collage. This little armadillo uses lots of **different patterns in a similar color theme**. I have drawn a template for the armadillo but you can make up your own animal. Look at photographs of the real creature and break its body down into simple shapes. I find sometimes it is best to **be spontaneous**, get cutting, and play around with the shapes, that's when the good things happen!

1 If you are using the template, enlarge it, trace it, and transfer the shape to a sheet of letter-size (A4) paper (see Enlarging a Template, page 118). Fill the body area with sections of patterned paper and glue them in place.

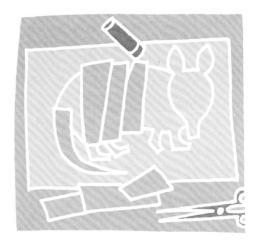

❀ When cutting strips of patterned paper to fill the body shape in Step 1, you can use the trace from the template to help you get the shape right, but it doesn't matter if some bits of collage are different lengths and go over the lines. That's part of the look.

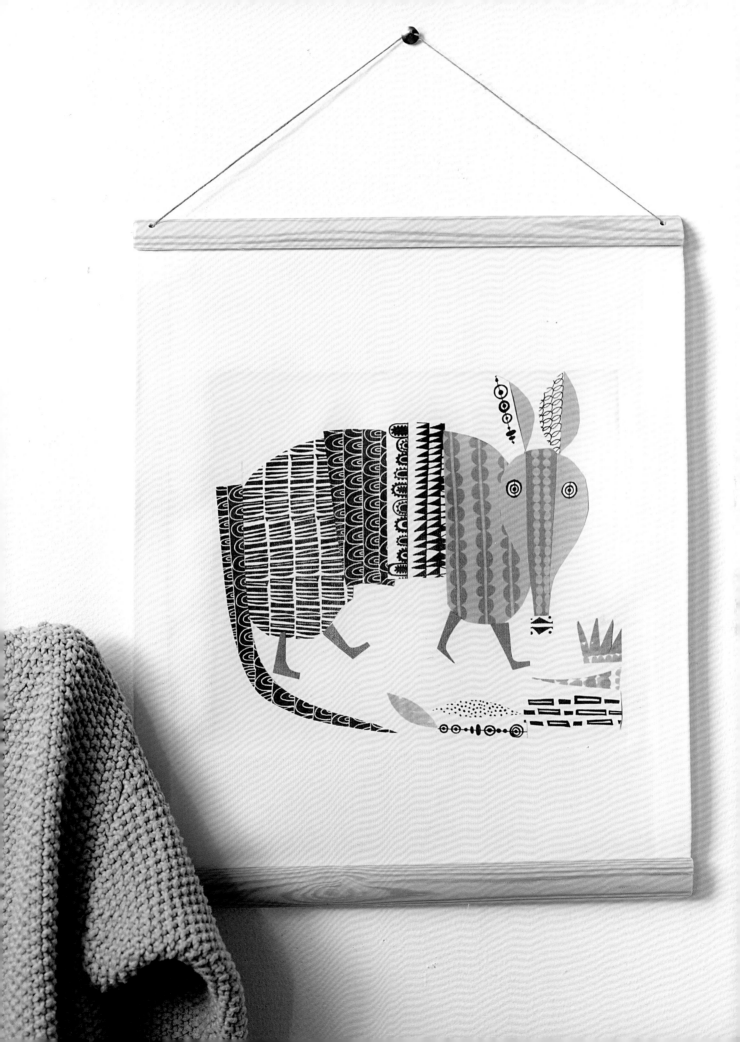

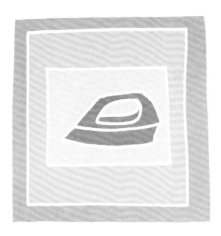

2 When you have finished your collage, follow the instructions for the photo transfer paper to print the collage on the right side. Place the transfer at the center of the fabric and iron in place. Again, follow the manufacturer's instructions.

3 On the fabric, turn in a seam the width of the hemming tape and iron flat. Thread a length of tape into each of the hems. Follow the instructions to iron down the tape, so securing the seams.

4 Drill two holes in one of the wooden batons, ½ in. (1 cm) in from each side edge. Thread some string through the holes to make a hanging loop and tie two knots to secure.

5 Run wood glue along the backs of the batons and stick them to the top and bottom of the fabric to complete the hanging.

FRUITY CUTOUTS

You don't have to look far to find some great material for making collages. **Pick up an old magazine and tear out the colorful pages**. I like to use sections of text on bright backgrounds, mixed in with plain and patterned papers. For this cutout-card project, I show you how to stick papers in three ways to create stunning effects. I sorted my collection of papers into piles of different colors, choosing mostly **green and yellow** for the pear, **pink and orange** for the pineapple, and **yellow and black** for the banana.

▼ YOU WILL NEED

- ○ 3 sheets of colored card stock (card) measuring 12 x 6¾ in. (31 x 17 cm)
- ○ Pencil
- ○ Ruler
- ○ Blunt knife, or similar, for scoring
- ○ Templates, page 124
- ○ Tracing paper
- ○ Masking tape
- ○ Craft knife
- ○ Cutting mat
- ○ Collage scraps in different colors
- ○ Scissors
- ○ Glue stick

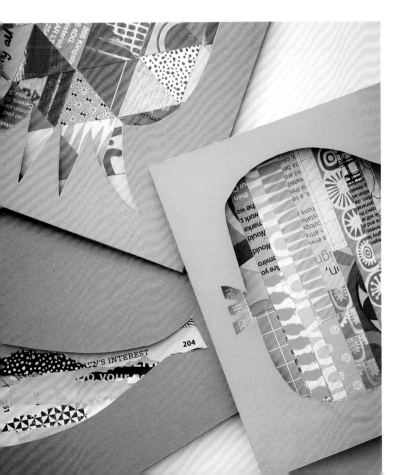

1 To make the pineapple card, use a pencil and a ruler to mark the center of each long edge of a sheet of card stock (card). Use the blunt knife and the ruler to score the card between the two marks.

2 Trace out the pineapple template and transfer it to the front of the folded card, positioning it in the center. Use the craft knife to cut out the shape, protecting your work surface with a cutting mat.

3 Cut out a number of small triangles from your paper scraps. I make a card stock (card) template to cut around using a small pair of scissors. Lay several papers on top of each other to cut a few triangles at a time.

4 Cover the inside of the card with triangles, working in rows from the centerfold.

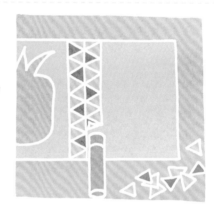

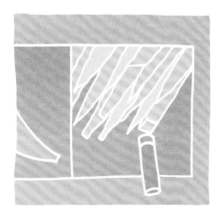

5 Follow Steps 1 to 4 to make the banana card. To make the collage, use small sections of torn paper.

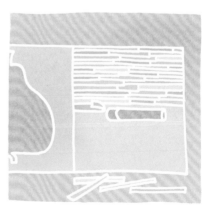

6 Follow Steps 1 to 4 to make the pear card. Covering the inside of the card by sticking small strips of paper in rows.

GET CREATIVE

This project lends itself nicely to a whole range of variations. Big letters or numbers work well and make lovely personalized cards for friends. Find a suitable letter or number in a magazine and enlarge it to the right size. Alternatively, you could print one from your computer.

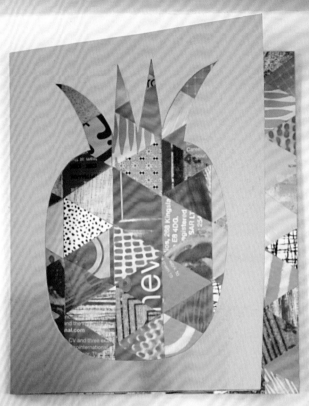

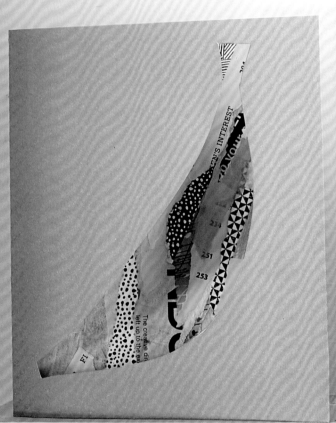

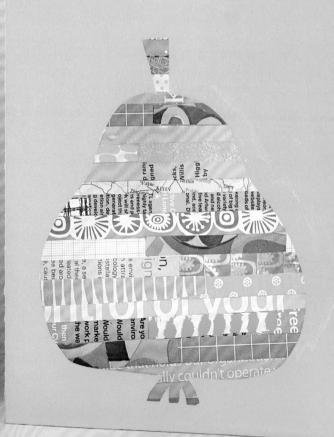

PHOTO MONTAGE

You can achieve some very interesting effects by **transferring images onto wood**. The technique is easy to learn and great fun to experiment with. You need a pot of photo transfer medium, which you can buy at most craft suppliers. I made the house shape by cutting a simple roof from an offcut of wood. To **add some layering** to the collage, I printed one of the photographs onto tracing paper.

▼ YOU WILL NEED

- ○ An offcut of wood
- ○ Ruler
- ○ Pencil
- ○ Wood saw
- ○ Sandpaper
- ○ Photocopies of photographs
- ○ Newspaper
- ○ Photo transfer medium
- ○ Paintbrush
- ○ Small bowl of water
- ○ Small sponge
- ○ Tracing paper
- ○ PVA glue

1 Use a ruler and a pencil to mark out a roof shape on your piece of wood. Cut the shapes using a wood saw and sand away any rough edges or splinters.

2 Place a photocopied photograph on a flat surface, with the image facing upward. You should protect your surface with some newspaper. Brush a thick layer of the photo transfer medium onto the photograph.

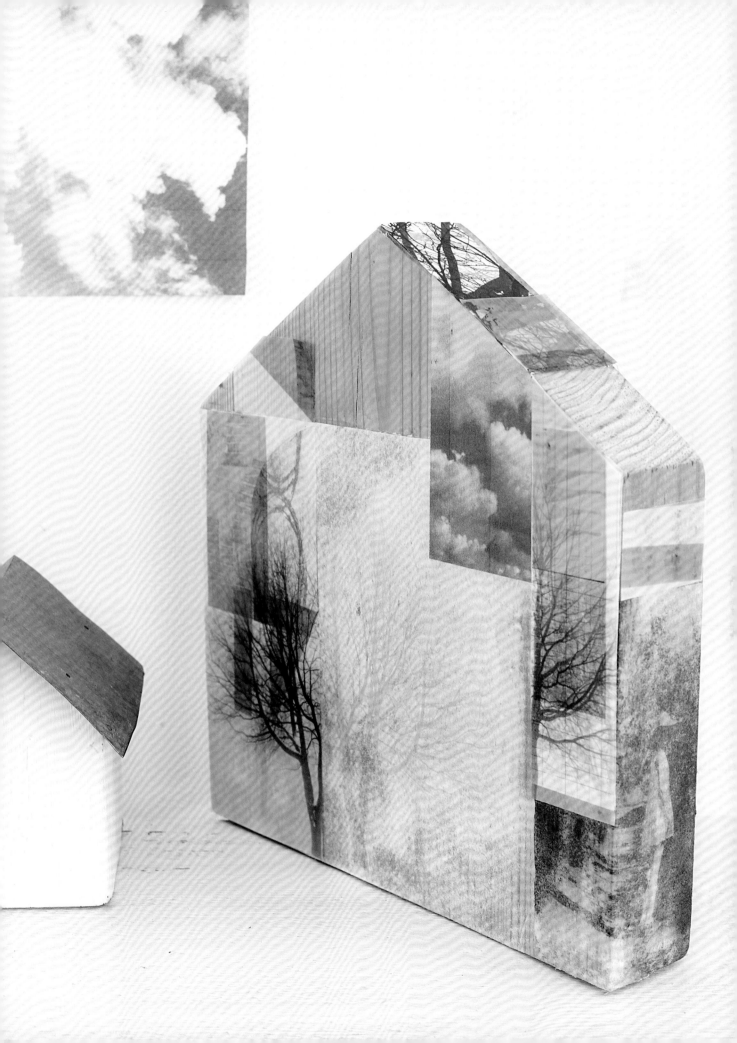

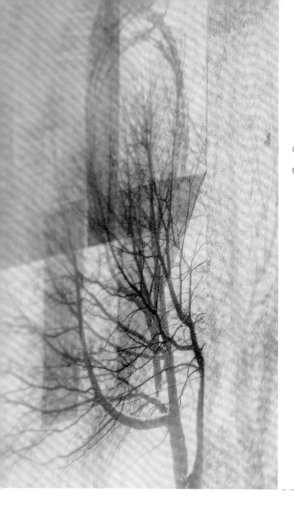

3 Gently lift the well-covered photo and place it face down in your chosen position on the wooden block. Press it down, smoothing out any wrinkles or air bubbles.

4 Repeat Steps 2 and 3 with any other photos you want to add to the block. I placed a tree on the front and a figure on the side edge. Leave the photos to dry for at least six hours or overnight.

5 With a small bowl of water, use a sponge to wet the photo, gently rubbing away the paper. This is quite exciting! The paper comes away in small rolls, revealing the image on the wood. Repeat with any other photos you added to the block.

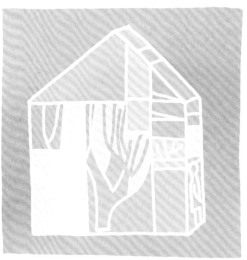

6 Add more interest to your block by cutting and sticking sections from photocopied images and introducing more layers by adding images photocopied onto tracing paper. Move pieces around, adding and taking away, until you are happy with the arrangement. When you are pleased with the position of everything, you can glue all the pieces in place.

SCRAP-PAPER CRITTERS

▼ YOU WILL NEED

○ Templates, page 122

○ Tracing paper

○ Masking tape

○ Pencil

○ Ruler

○ Thin card stock (card)

○ Scissors

○ Scraps of paper, including some sparkly paper or foil

○ Glue stick

○ Blunt knife, or similar, for scoring

○ Craft knife

○ Cutting mat

○ Collection of lichen-covered twigs

○ Wood glue

When I was a child, I saw **butterflies and beetles** displayed in glass cases in a museum. The cases were covered in sheets of dark felt to protect the insects from the light. You drew back the felt to reveal their beautiful **iridescent wings** and bodies. They fascinated me and I have never forgotten them. In my collection of found papers I have some **candy wrappers** and their metallic colored foil reminded me of those beautiful winged creatures, so I decided to make my own collection. Use whatever scraps of paper you have to collage the insects. I like to include **translucent paper**, such as printed tracing paper for wing sections.

1 To make the big dragonfly, trace out the templates and transfer the body section onto some card stock (card). Cut the shape out using scissors.

2 Cover the body shape with small scraps of colored paper and foil. Use glue to stick the scraps in place and trim any that overlap the edge of the card.

3 Use the blunt knife to score down the center of the body and fold in half. Cut out two antennae from colored paper and stick them down at the top of the head section.

4 Use the template to cut out three wing shapes. I cut two from card stock (card), which I covered in scraps of paper, and I cut one from some printed tracing paper. Use a craft knife to cut the shapes and protect your work surface with a cutting mat.

GET CREATIVE

Why not frame your critters, just like those ones in the museum? You can buy shadow boxes for display. Simply glue a square of foam board to the back of each critter and pin to the backing board inside the box.

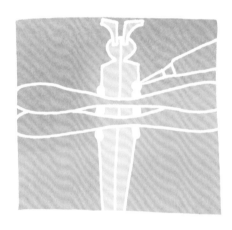

5 Run some glue down the inside edges of the body section and stick the wings in a row, slightly overlapping one another.

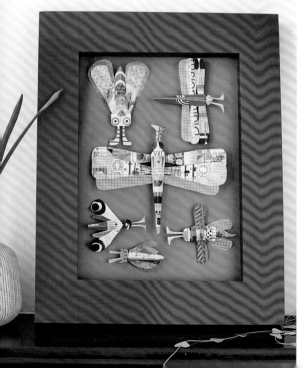

6 Follow Steps 1 to 5 to make a number of insects of different sizes; vary the shapes and sizes of the wings and bodies.

7 Display your critters inside a shadow box (see left), or create a more natural setting for them. Arrange them on a pile of lichen-covered twigs and use dabs of wood glue to hold them in place.

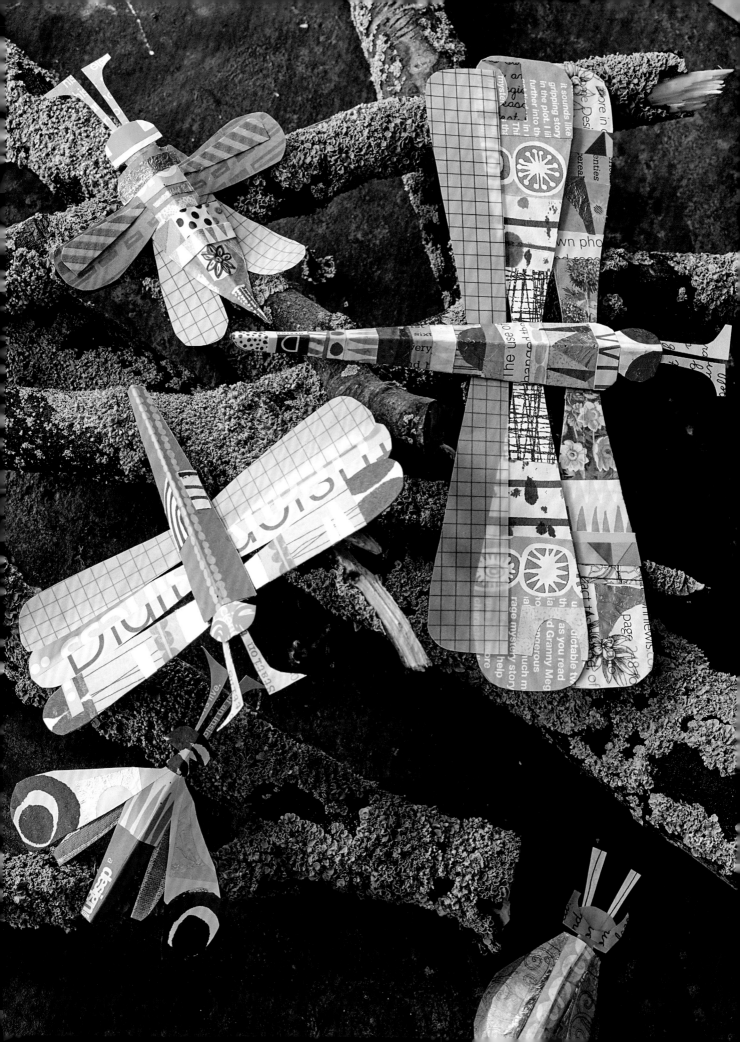

MONTAGE MOBILE

Photo clip mobiles offer a wonderful way of displaying small collages—you can buy them online. I have made up a series of artworks using a variety of **mixed media**: scraps torn from old magazines; leftover hand-printed pieces; shapes cut from tissue paper; photographs; text printed onto tracing paper; and patterns drawn up in pen and ink. Really, **anything goes**. Some of my artworks use shapes cut and stuck down to form **abstract patterns**, while others use **layers of tissue and printed tracing paper** to create an interesting effect. The different styles work together, because I have limited the color palette to black, white, and green.

▼ YOU WILL NEED

- ❍ Thin white card stock (card)
- ❍ Ruler
- ❍ Pencil
- ❍ Craft knife
- ❍ Cutting mat
- ❍ Scraps of paper in your chosen colors
- ❍ Scissors
- ❍ Glue stick
- ❍ Photo clip mobile

1 Use a ruler and a pencil to measure a number of rectangles and squares on the white card stock (card). The three sizes I have used measure $4\frac{3}{4}$ x $4\frac{3}{4}$ in. (12 x 12 cm), $5\frac{1}{2}$ x $3\frac{1}{2}$ in. (14 x 9 cm), and $4\frac{3}{4}$ x 3 in. (12 x 8 cm). Cut them out using a craft knife and protect your work surface with a cutting mat.

2 Cut shapes from scraps of colored paper and stick them on both sides of the white card stock (card) to make collages. (See Composition, pages 21–25).

3 Clip the collages to the mobile, ready for hanging.

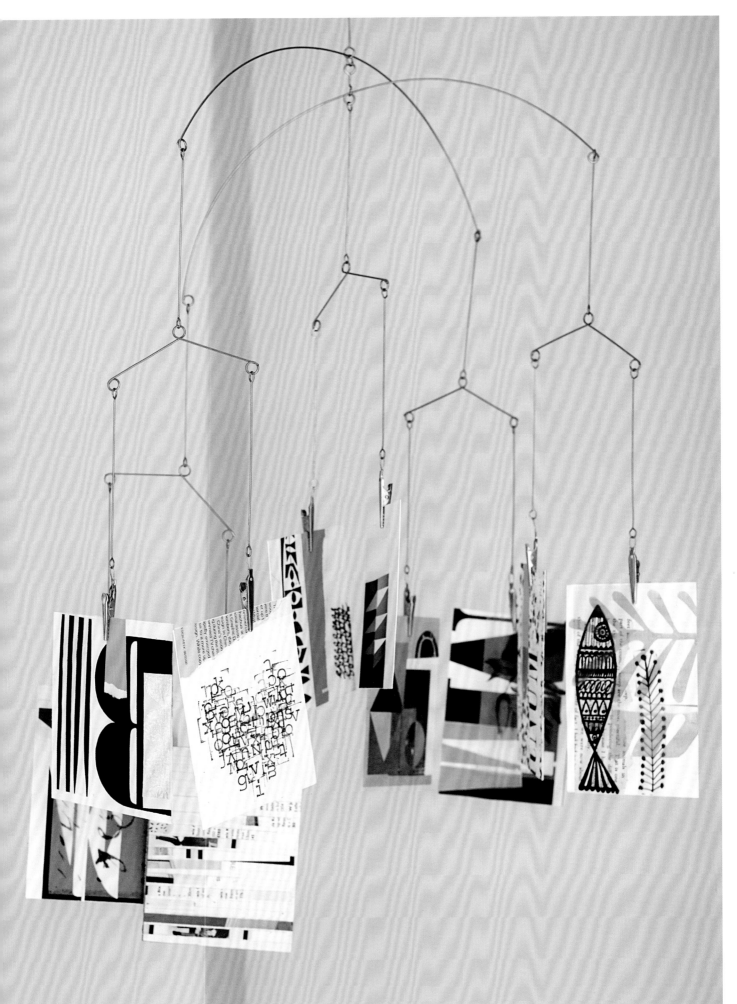

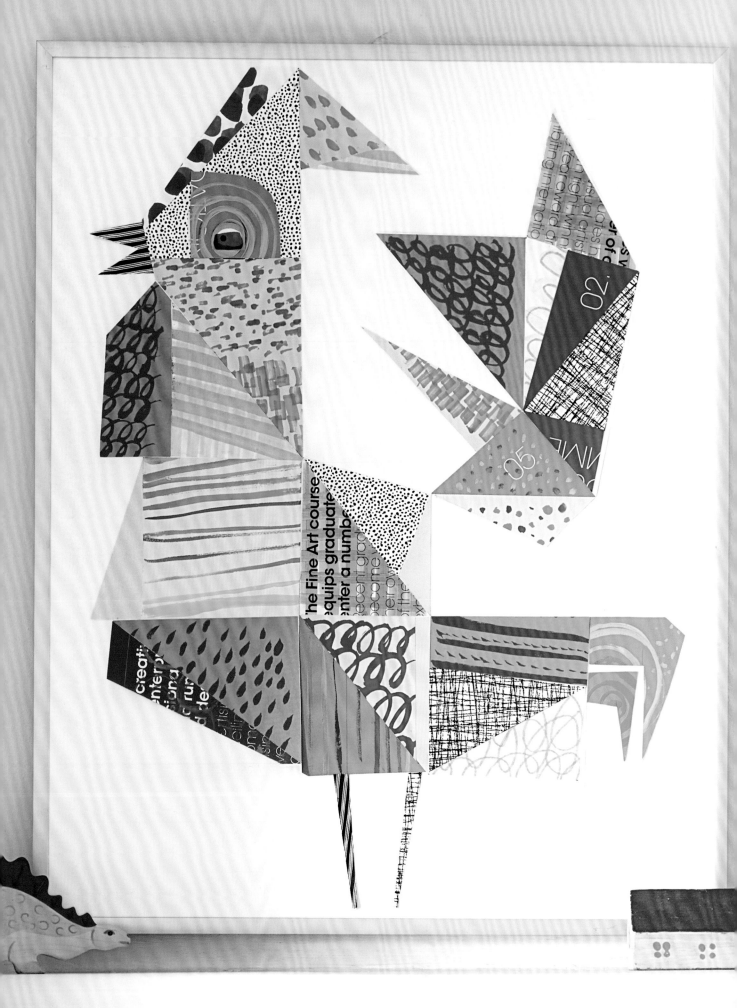

GEOMETRIC BIRD

This is a great project to make using **hand-printed papers** (see Decorative Papers, page 13). I used **simple cutout shapes—mostly triangles**—and arranged them in the shape of a bird. Use my bird as a starting point, if you like, or invent your own. Cut a number of different shapes and arrange them on a sheet of paper, adding or removing pieces as you move them around. Something will start to emerge that you can build on—it may not even become a bird but take the shape of a tiger or a boat instead. I often work in this way, not knowing what the finished piece will be and just **letting the shapes direct me**. It is a lovely, liberating way to create.

▼YOU WILL NEED

○ Colored and painted papers

○ Scissors

○ Ledger-size (A3) sheet of paper or thin white card stock (card)

○ Glue stick

To make the T-shirt

○ Letter-size (A4) sheet of photo transfer paper for pale-colored T-shirts

○ White T-shirt

○ Iron

1 Cut triangles and rectangles from colored and painted papers. Offcuts from previous collages are great, too.

2 Start arranging the shapes on the sheet of paper or card stock (card), adding different shapes or cutting into the shapes you have already laid down.

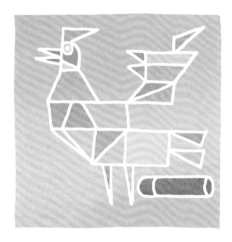

3 When you are happy with the design, stick the shapes in place. I usually leave the eye to last. The piece is now ready to frame.

4 **To make the T-shirt**, photocopy the collage, reducing it to fit a letter-size (A4) sheet of paper. My collage was quite big, so I copied it in sections.

5 Follow the instructions for the photo transfer paper to iron the design onto the T-shirt.

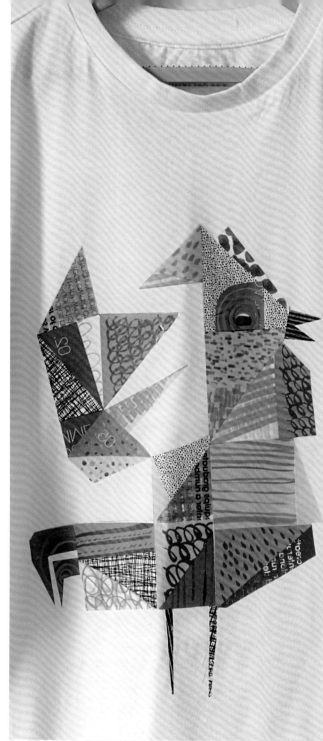

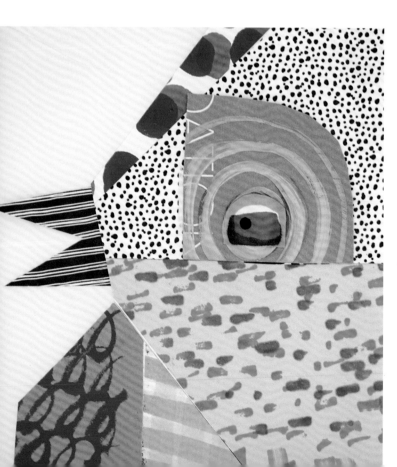

GET CREATIVE

This is a great way to use some of your kids' artwork. Cut shapes from the most colorful sections—the more abstract the better—and stick them down to make a bird or animal shape. Photocopy the artwork first, if you don't want to cut it up.

NAMES IN LIGHTS

These collaged letters are easy and fun to make. I used the **brightest pieces** of paper I could find in my scrap box, including **eye-popping neons**, **hand-painted scraps**, and **colored graph paper**. The main body of each letter is cut from an area of text in an old magazine. The bold colors really stand out against the black background.

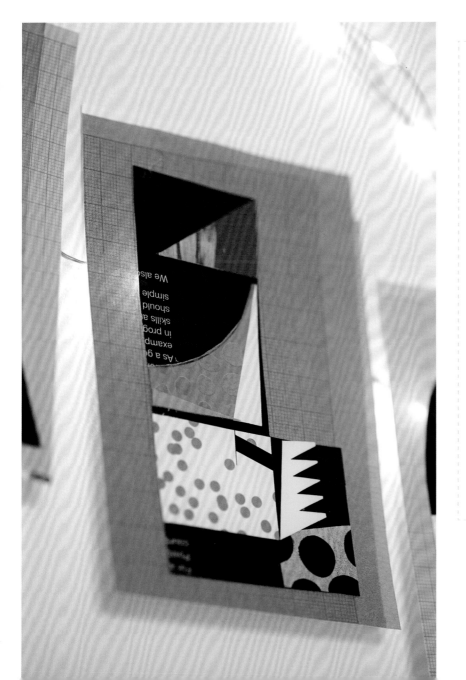

▼ YOU WILL NEED

- ○ Thin cardboard
- ○ Ruler
- ○ Pencil
- ○ Craft knife
- ○ Cutting mat
- ○ Scraps of colored paper
- ○ Glue stick
- ○ Pages from a magazine in a dark color
- ○ Scissors
- ○ String of fairy lights (optional)
- ○ Washi tape (optional)
- ○ Sticky tack (optional)

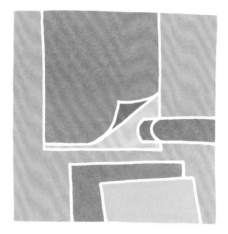

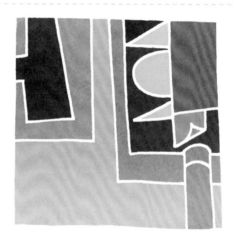

1 Cut some rectangles measuring 5½ x 3½ in. (14 x 9 cm) from the cardboard. Use a craft knife and protect your work surface with a cutting mat. Cover the pieces with colored paper.

2 Cut out your letters. I like to use magazine pages that have white type on a black background. You don't need to be too precious about the shapes of the letters —a little character is a good thing.

3 Stick the letters to the covered rectangles and decorate them using scraps of colored paper. Make sure each letter shape is still legible.

4 To make an illuminated feature, work a string of LED fairy lights into a heart shape, securing the wires to the wall using small pieces of washi tape. Use sticky tack to stick the letters to the wall within the heart shape.

✿ To make colored graph paper, stick rectangles of colored paper to a letter-size (A4) sheet of paper and photocopy this onto a sheet of graph paper.

✿ If you don't want to draw your own letters, print some from your computer and trace over the shapes.

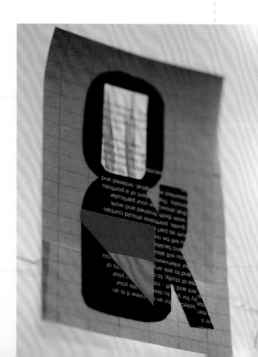

GET CREATIVE
You can use individual letters to make greetings cards and tags.

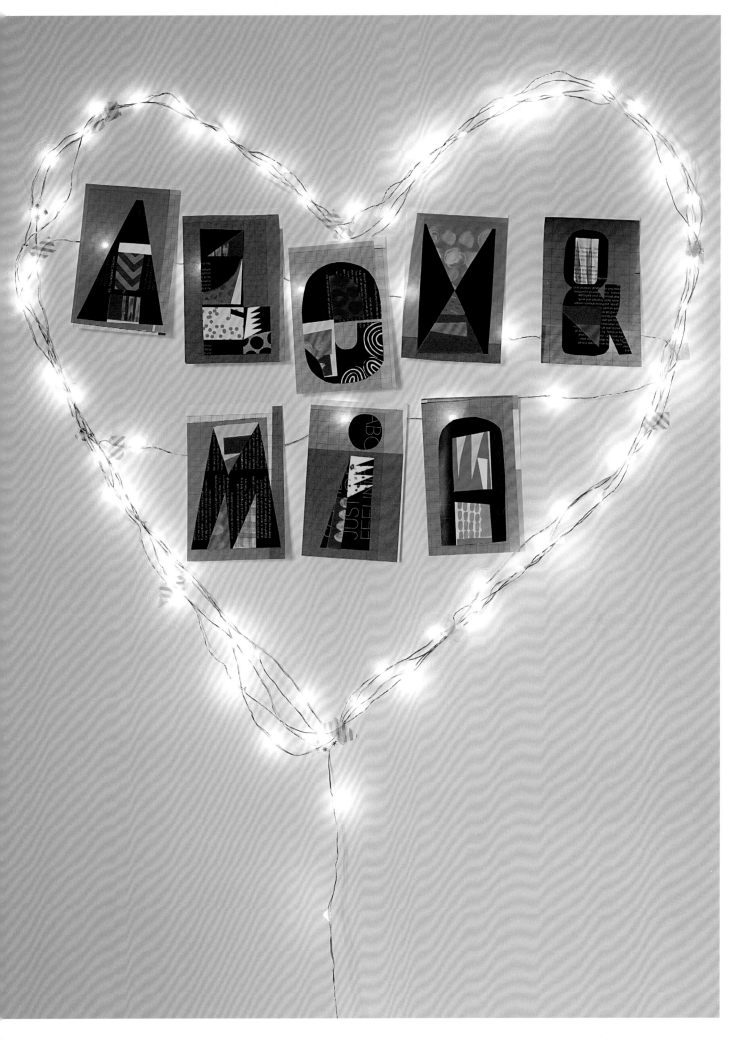

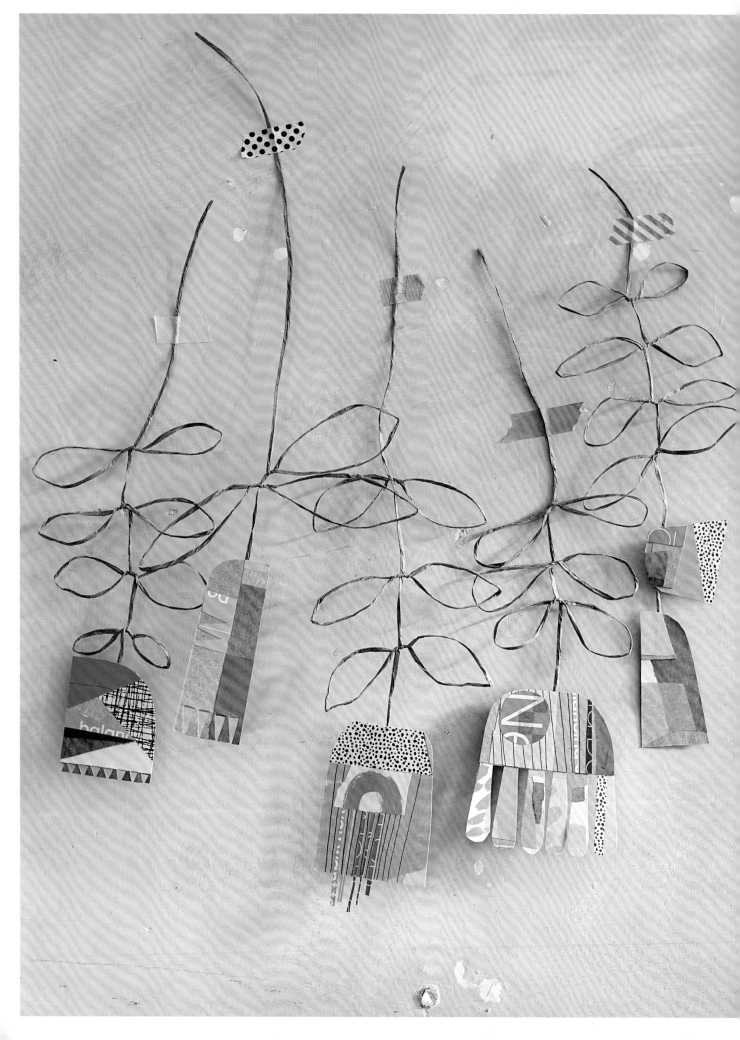

DECORATIVE FLOWERS AND LEAVES

These pretty decorations are fun to make and the creative possibilities are endless. I have used **copper wire** and **paper-covered wire** to make stems for them. You can **twist them around glass jars** or wrapped gifts, string them along a length of ribbon to **make a garland**, or **wrap them around napkins** to make gorgeous place settings. This is a good project for using up **small leftover snippets** of paper from other projects that are too beautiful to throw out. Use the templates if you like, or experiment to make your own flower shapes.

▼ YOU WILL NEED

○ Copper or paper-covered wire

○ Wire cutters

○ Templates, page 121

○ Tracing paper

○ Masking tape

○ Pencil

○ Thin card stock (card)

○ Scissors

○ Selection of printed and patterned papers

○ Glue stick

○ PVA glue

1 To make a stem, cut a length of wire measuring 31½ in. (80 cm). Starting 8 in. (20 cm) from one end, bend the wire into a leaf shape.

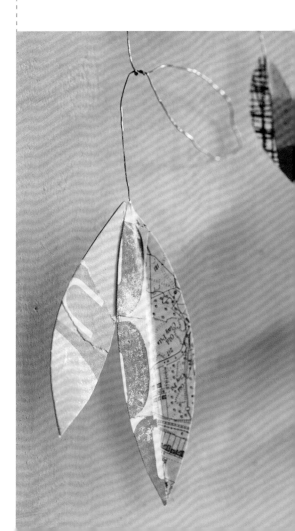

2 Make a few twists in the wire at the base of the leaf, to secure its shape. Make another leaf shape on the opposite side of the stem. Repeat to make as many leaf shapes as you like.

3 Trace out the shapes for the flowers and leaves and transfer them onto some card stock (card). For each flower, or set of leaves, you need to cut two identical shapes. Cut the shapes out using scissors.

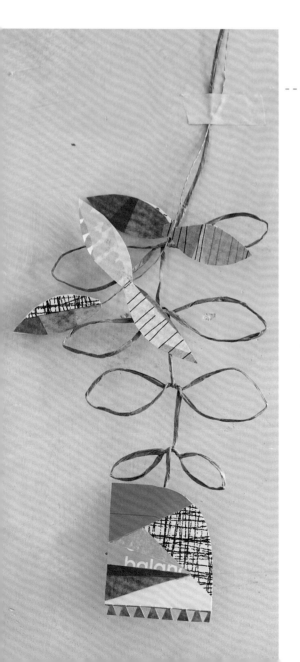

4 Cover the card shapes with cutout bits of printed and patterned paper—use a glue stick to stick them down.

5 Use PVA glue to stick two identical card shapes together, sandwiching the wire between them.

PARTY BAGS

These party bags are great fun to assemble and are **perfect for kids** of all ages. Create them yourself or make up the basic bags with the photographs and get each kid to collage his or her own as a **party game**.

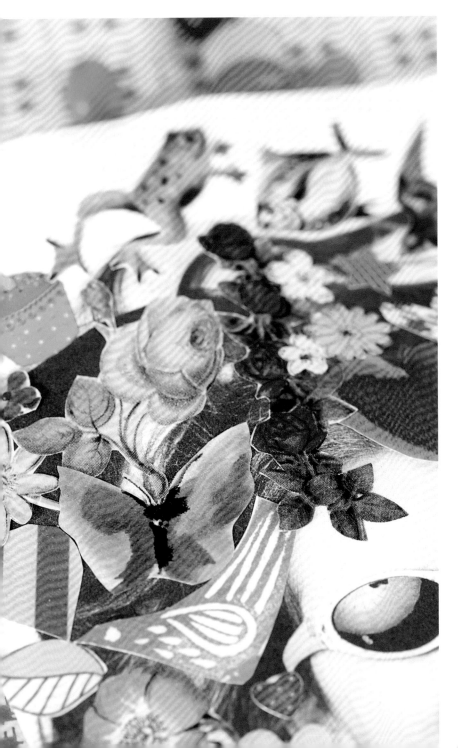

▼ YOU WILL NEED

○ Half-letter-size (A5) black-and-white photographs

○ Letter-size (A4) sheets of paper

○ Glue stick

○ Scraps cut from magazines, old books, giftwrap, packaging

○ Scissors

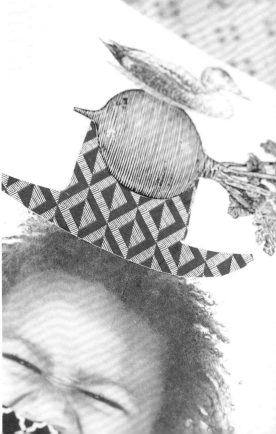

1 Photocopy a photograph so that it prints on one half of a letter-size (A4) sheet of paper.

2 Make a bag by folding the sheet of paper in half and running glue along the bottom edge and the side opposite the fold.

3 Cut images from your scraps of paper and stick them down on the photograph.

4 On one of the faces I have stuck a mustache and a hat shape cut from some patterned paper.

GET CREATIVE

• Print out some extra photographs to decorate. Attach them, evenly spaced, along a length of bright ribbon, to string up as colorful party bunting.

• Complete the party theme by printing out some faces onto letter-size (A4) paper. Stick the sheets together and decorate. You can then use this as a runner down the center of the birthday-tea table.

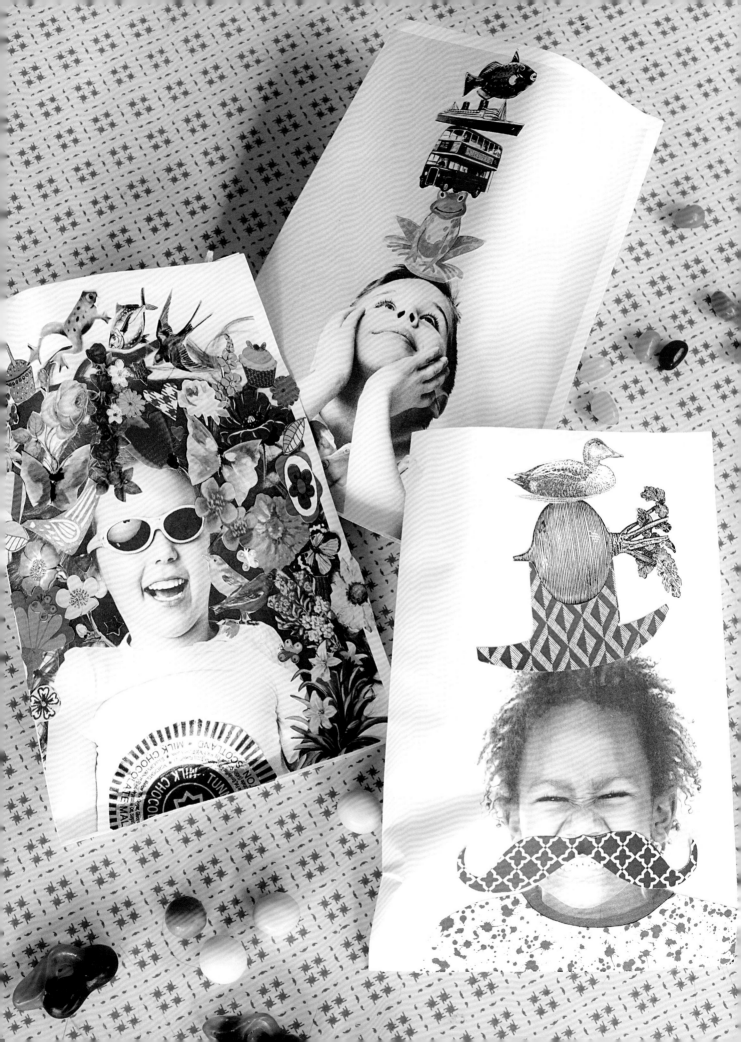

STACKING BLOCK COLLAGE

YOU WILL NEED

- ○ Offcuts of wood. Mine are taken from wood measuring $3\frac{1}{2}$ x $1\frac{1}{2}$ in. (8.5 x 4 cm). The individual blocks range from 4 to 5 in. (10 to 13 cm) in length

- ○ White paint (optional)

- ○ Paintbrush (optional)

- ○ Black-and-white photographs

- ○ Letter-size (A4) sheets of colored paper

- ○ Tracing paper

- ○ Scissors

- ○ Glue stick

Simple offcuts of wood make a great alternative to framing when it comes to displaying your collages, enabling you to bring a group of images together to create a one-off art piece that can be **rearranged** and **moved around** in an ever-changing display. I have used **high-contrast black-and-white photographs** for a strong visual impact and added a minimal palette of colors to tie the images together.

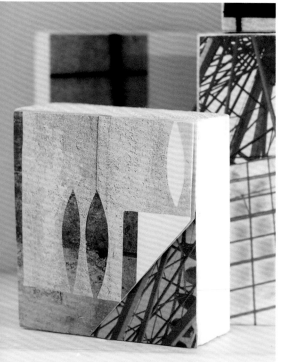

1 Paint the sides of the wood blocks if you'd like to, and let dry.

2 Print your chosen photographs onto a selection of colored paper and tracing paper. I changed the sizing of some of the printouts, to make graphic abstract shapes.

3 Cut your pictures into pieces for creating collages on the blocks of wood. I cut my images into rectangles, squares, and triangles, and played around with the different shapes on the blocks.

4 When you are happy with the arrangements, stick down the different sections. I like to overlay with printed tracing paper for a more complex effect.

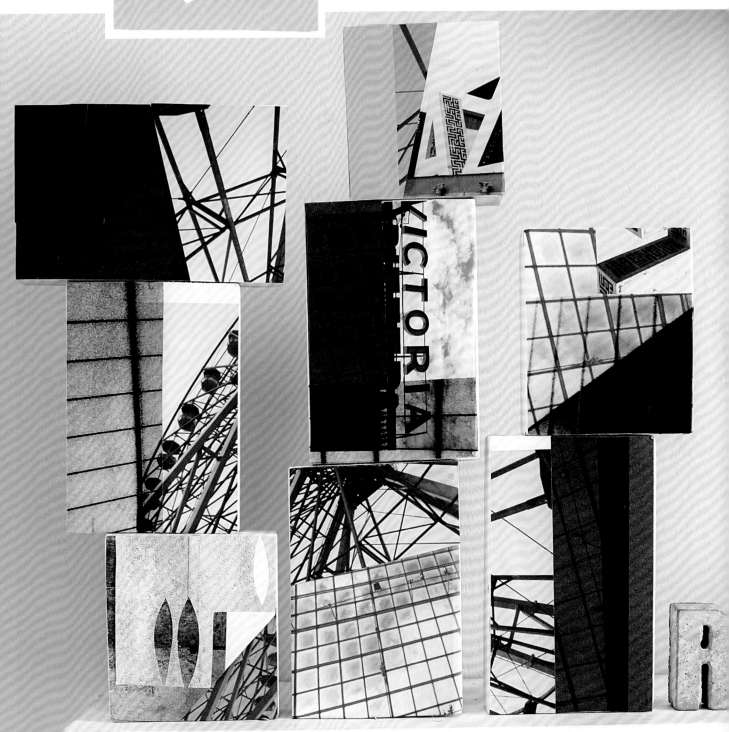

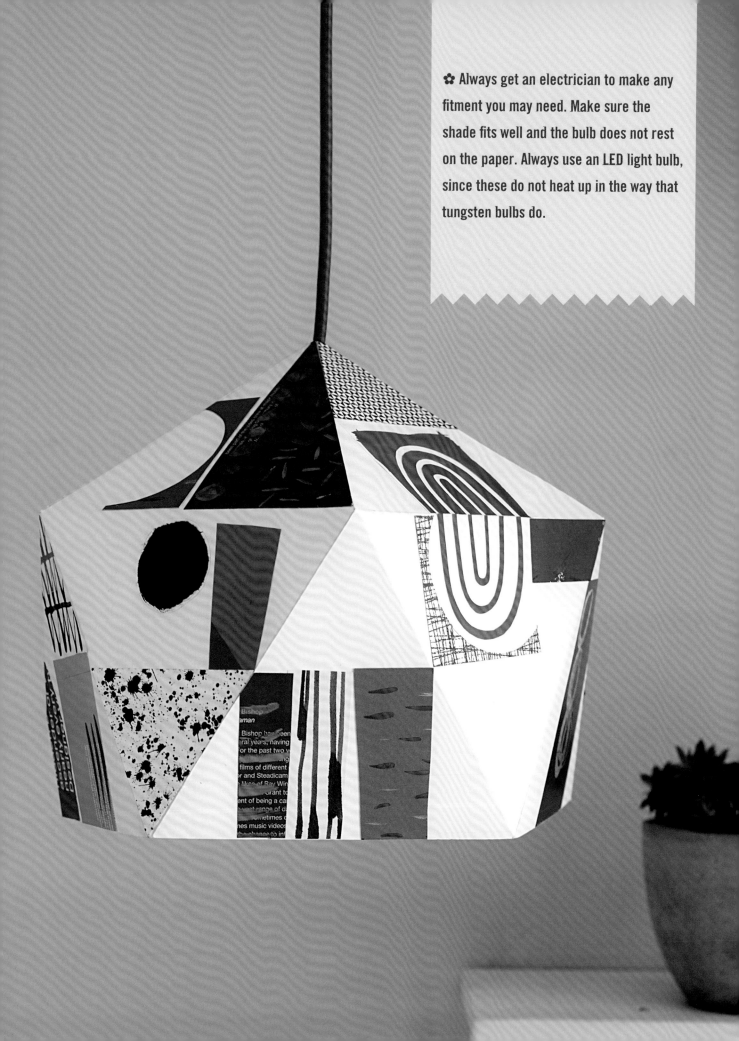

✿ Always get an electrician to make any fitment you may need. Make sure the shade fits well and the bulb does not rest on the paper. Always use an LED light bulb, since these do not heat up in the way that tungsten bulbs do.

FOLDED LAMPSHADE

Making a lampshade is surprisingly easy. For mine, I have covered a white card stock (card) form in sections of collage using a mix of **black, orange,** and **gray paper**. Teamed with a cool **orange cable,** the lampshade makes a **striking and contemporary** addition to any interior. Cables come in a huge range of colors so you are bound to find one that suits your style.

1 Enlarge the template, stick it down on a piece of thin card stock (card), and use scissors to cut it out.

2 Use the template you have made to construct the flat shape of the lampshade. It is drawn in two sections that join together along one of the glue flaps. Use a triangle (set square) to draw three parallel lines across the base card, 5½ in. (14 cm) apart. Draw in the two rows of triangles using the pencil lines as a guide and following the layout guides on page 125. Make sure you use a sharp pencil and a ruler.

▼ YOU WILL NEED

- ○ Templates, page 125
- ○ Large sheets of thin white card stock (card)
- ○ Glue stick
- ○ Scissors
- ○ Triangle (set square)
- ○ Pencil
- ○ Ruler
- ○ Craft knife
- ○ Cutting mat
- ○ PVA glue
- ○ Blunt knife, or similar, for scoring
- ○ Colored paper—painted samples and sections cut from magazines

3 Cut out the two flat sections using a craft knife and protecting your work surface with a cutting mat. Run PVA glue along the flap that is marked on the template and join the two sections together.

4 Score along all the lines marked with a dotted line on the template.

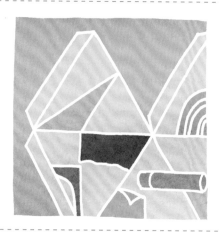

5 Cut abstract shapes from the colored paper samples and use these to decorate the panels.

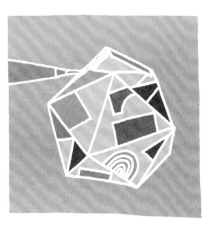

6 Fold the triangles along the scored lines to make up the shape. Glue and stick the flaps as you go, leaving one triangle unglued.

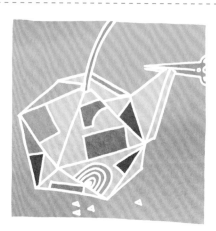

7 Place the light fitment inside the shade. Snip the tips of the triangles to allow for the cable and then glue the last triangle in position.

GET CREATIVE

This project is a good one to mix and match with others.
You could make each panel a different patterned paper for
a patchwork effect, or use pretty floral illustrations mixed
with old script lettering to fit perfectly with a botanical
theme in a room.

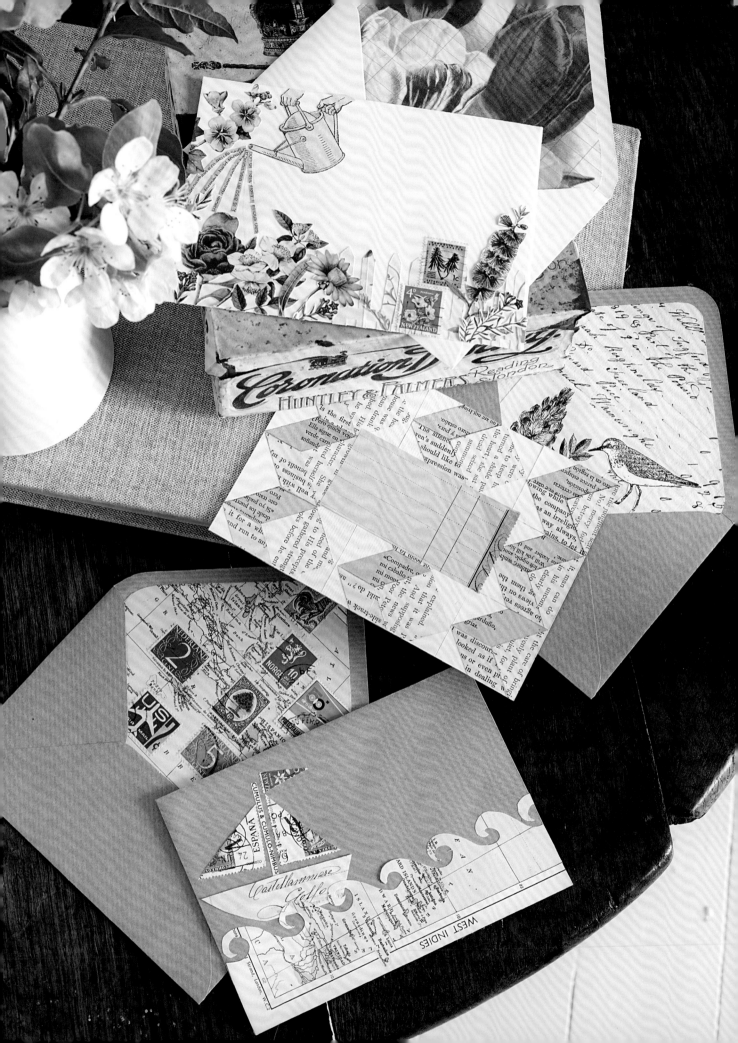

SNAIL MAIL

In this age of text messages and emails, it is always lovely to receive a personal letter by mail. Decorate yours with a series of collages, to **elevate the humble envelope** into something so special, that it will always be treasured.

▼ YOU WILL NEED

○ Envelopes

○ Tracing paper

○ Ruler

○ Pencil

○ Scraps of paper from old books and magazines

○ Scissors

○ Glue stick

1 Make a template for the lining of your envelope: Lay tracing paper over an open envelope and trace around the inside edge of the gum strip and extend the side edges just two-thirds into the depth of the envelope. Use a ruler and pencil to make sure you get crisp, even lines, although you can hand draw the curves. Draw a line across the bottom.

2 Use the template to make linings for the envelopes. For the floral envelope lining, I photocopied flowers onto graph paper. For the nautical lining, I cut a section from an old map and added some stamps. For the book-themed lining, I photocopied some writing from an old receipt and added black-and-white botanical and bird illustrations. Apply glue to the back of each lining, slip it down into its envelope, and press down to secure.

3 To make the floral envelope design, I arranged a number of cutout flowers and added a picture of a watering can to the front of the envelope. Make sure you leave space for the address and the stamp.

4 For the nautical envelope, I cut a little boat with sails from an old postcard. The sea is cut from an old atlas.

5 For the book-themed envelope, I made up a geometric grid and used different pages from old books to fill it in. Subtle changes in the color of the pages create a 3-D pattern. I used a piece of lined paper from an old ledger for the address space.

GET CREATIVE

Try making your own envelopes from scratch. Simply ease open the glued section on a bought envelope and use this as a template. This way you can use different papers for the base. Pages from old books, music scores, and graph paper work well. You could experiment with printing onto tracing paper to make intriguing semitranslucent envelopes.

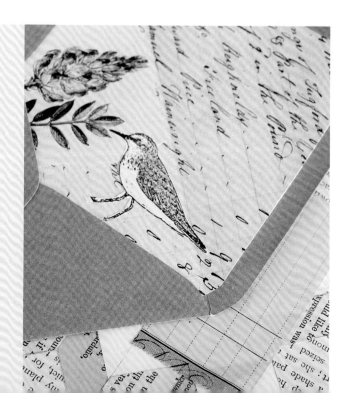

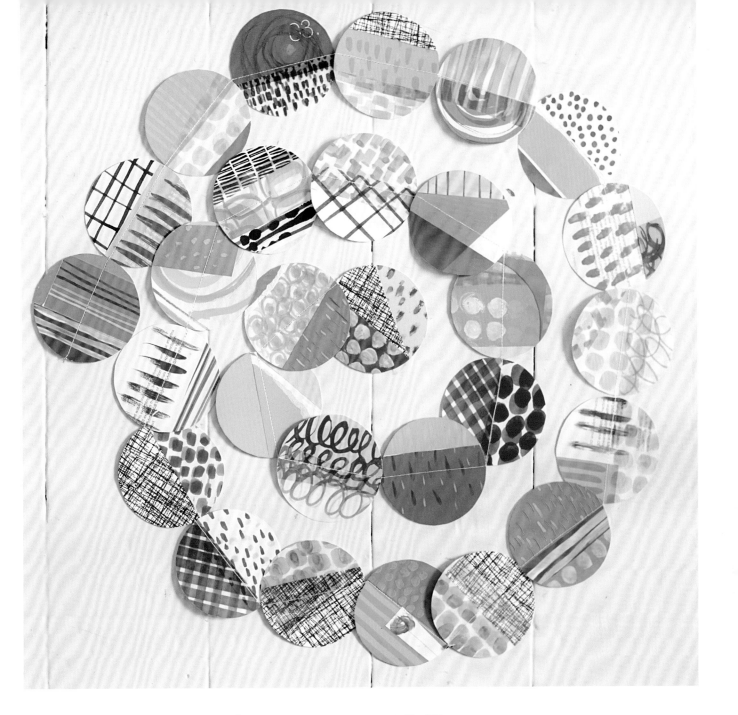

PARTY GARLAND

Use your brightest **scraps of paper** to make this collaged party garland. I have stitched mine together using a sewing machine—a quick and effective method for making a long garland. Alternatively, you could sandwich some thin ribbon or cord between glued-together disks.

▼ YOU WILL NEED

○ Scraps of paper

○ Scissors

○ Letter-size (A4) sheets of thin white card stock (card)

○ Glue stick

○ 3¼ in. (8 cm) circle template

○ Sewing machine

1 Cut scraps of paper into different shapes—enough to cover both sides of as many sheets of white card stock (card) as you intend to use. Stick the scraps in place.

2 Use the circle template to draw rows of circles to cover the card stock (card).

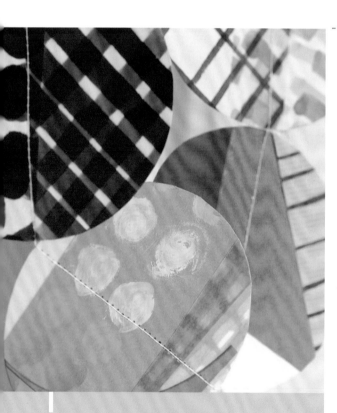

3 Cut out the circles.

GET CREATIVE

Make plenty of extra disks and use them to add to your party theme. Write your guests' names on individual disks to use as place settings. Stick a row of disks on a long sheet of paper to wrap around the celebration cake. Or why not cut different shapes? Stars, diamonds, and simple flower shapes would all make fun and colorful table decorations.

4 Sew the circles together using a sewing machine. Keep the line of stitching to the center of each circle and butt the circles up against each other.

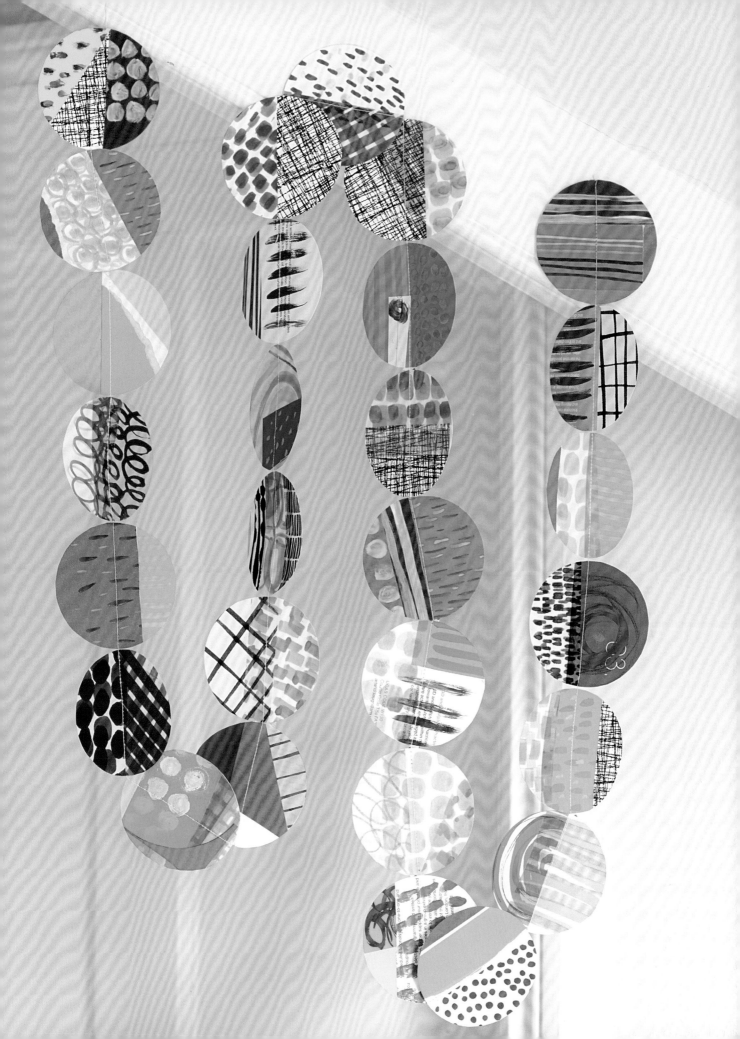

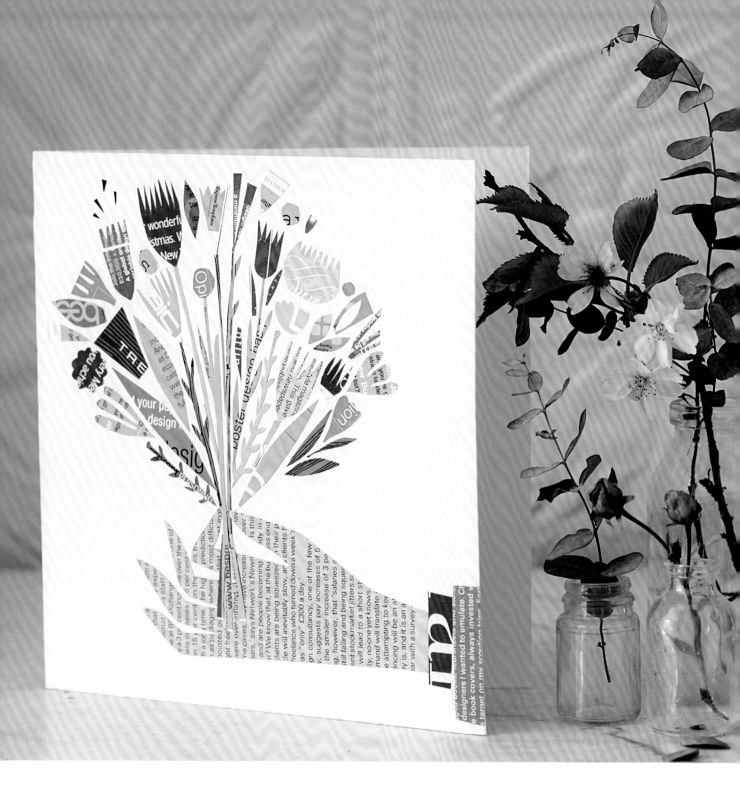

SPRING BOUQUET

Some of my favorite paper samples are cut from old magazines that I have rescued from the recycling. I like to use **areas of type on colored backgrounds**. Use the template for the hand and then fill the card with **flowers and leaves**.

▼ YOU WILL NEED

- ❍ Template, page 123
- ❍ Tracing paper
- ❍ Masking tape
- ❍ Pencil
- ❍ Paper samples cut from old magazines
- ❍ Scissors
- ❍ Thin card stock (card); it needs to be big enough to accommodate your design once folded in half
- ❍ Glue stick

GET CREATIVE

Stick individual leaves and flowers in clusters, over plain colored wrapping paper. Tissue paper would work well too. Make up tags with individual flowers on each one, to complete the set.

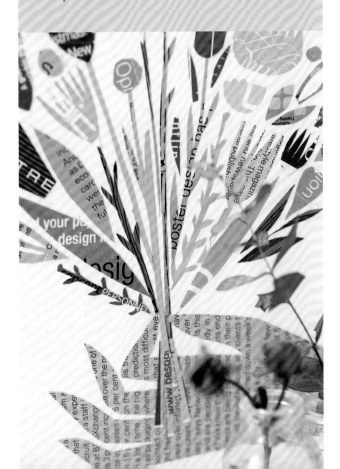

1 Trace out the hand template and transfer it onto patterned paper. Cut the shape out using scissors.

2 Fold the card stock (card) in half. Stick the hand down on the card stock (card) and add a cuff.

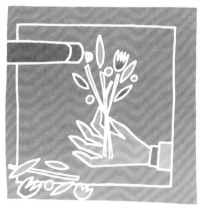

3 Cut out stalk, flower, and leaf shapes from your papers. I have kept my flowers very simple. Stick the shapes down to make a bouquet.

TEMPLATES

You will find all the templates you need on the following pages. Some of these are printed at actual size, but **some will need to be enlarged** using a photocopier before you work with them. The percentage by which they need to be enlarged is clearly labeled on every template. When a template is too big to enlarge in one go using a photocopier, you can enlarge it in sections on a number of sheets of paper and then join the sheets of paper together using clear tape. Alternatively, a template can be enlarged using the grid method (below).

ENLARGING A TEMPLATE USING THE GRID METHOD

1 Photocopy or trace your template—at the size it appears on the following pages—onto a letter-size (A4) sheet of paper.

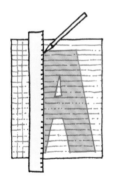

2 Mark points at ¾ in. (2 cm) intervals along the top and bottom of the sheet. Join the top and bottom points together using a pencil and ruler. Do the same down the two sides of the paper, joining the marks to make horizontal lines and forming the grid.

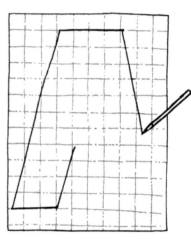

3 On a large sheet of paper or tracing paper, do the same, but this time make the marks with 1½ in. (4 cm) gaps. This will give you a template that is twice the size of your original (200%). To enlarge a template by 400%, make the marks with 3 in. (8 cm) gaps.

TRACING

For many projects you need to transfer a template onto paper or card stock (card), using tracing paper. Place a sheet of tracing paper over the template and secure with some masking tape. Trace the lines with a hard 4 (2H) pencil, then turn the tracing paper over and go over the lines again on the reverse with a softer pencil, such as a 2 (HB). Now turn the tracing paper over again and place it in position on your chosen paper or card stock (card). Go over all the lines carefully with the 4 (2H) pencil, and then remove the tracing paper. This will give you a nice, clear outline.

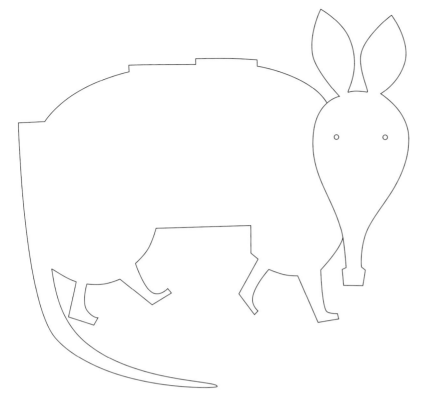

ARMADILLO FABRIC WALL HANGING

Page 78

Shown at 50%, enlarge by 200%

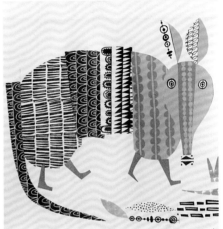

LITTLE NOTEBOOKS

Page 42

Shown at 50%, enlarge by 200%

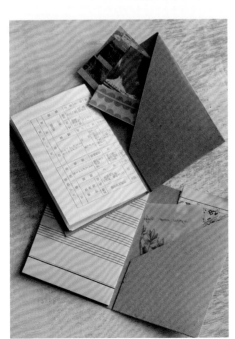

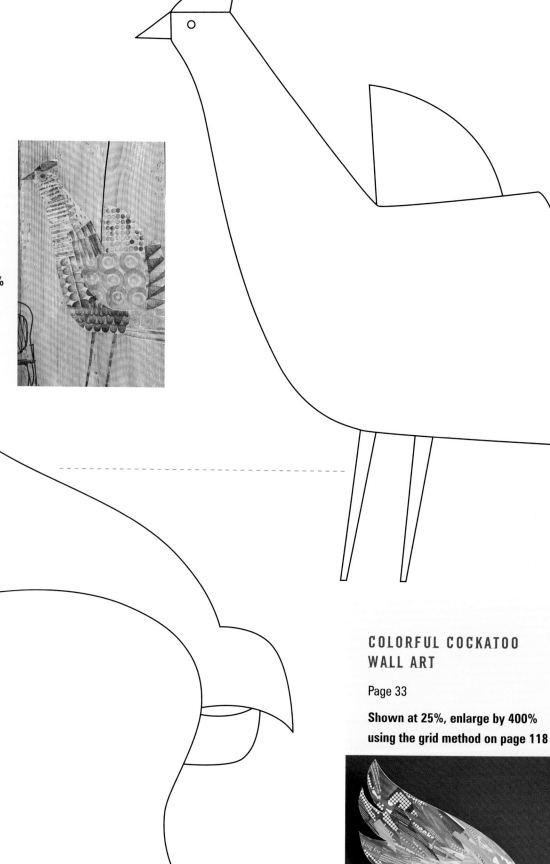

TEXTURAL BIRD

Page 48

Shown at 50%, enlarge by 200%

COLORFUL COCKATOO WALL ART

Page 33

Shown at 25%, enlarge by 400% using the grid method on page 118

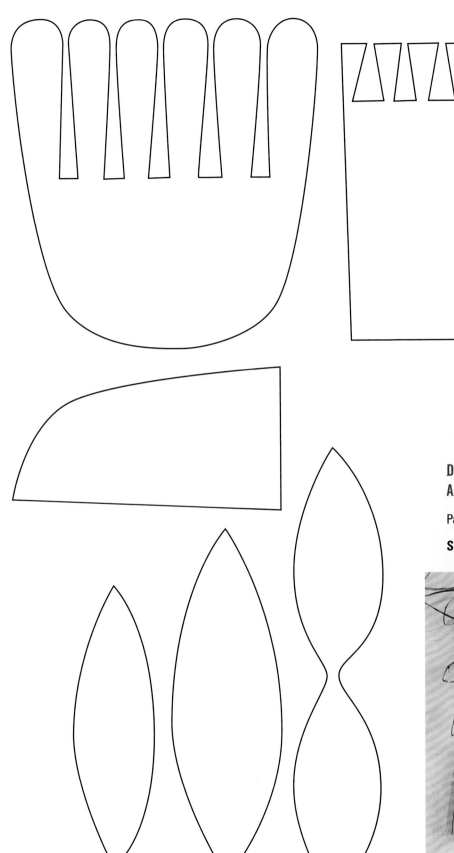

DECORATIVE FLOWERS AND LEAVES

Page 98

Shown at 100%

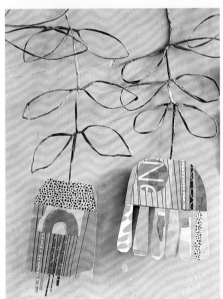

SCRAP-PAPER CRITTERS

Page 87

Shown at 100%

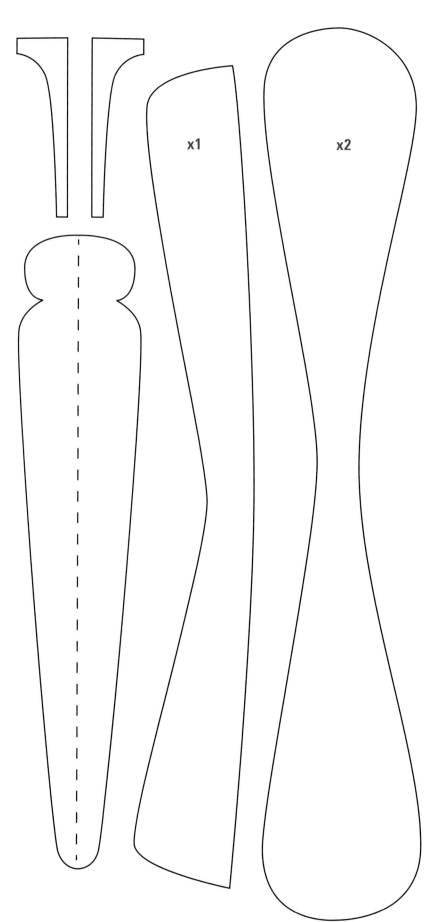

x1

x2

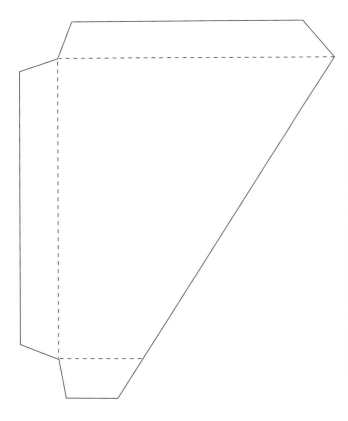

TRAVEL JOURNAL

Page 31

Shown at 50%, enlarge by 200%

SPRING BOUQUET

Page 116

Shown at 100%

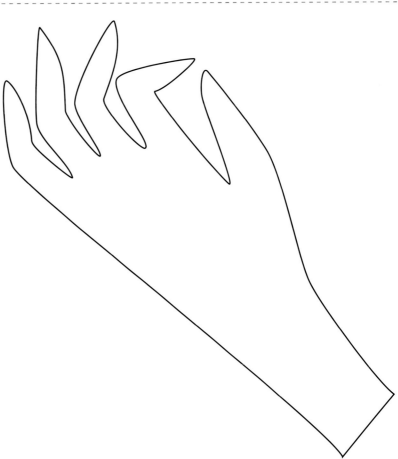

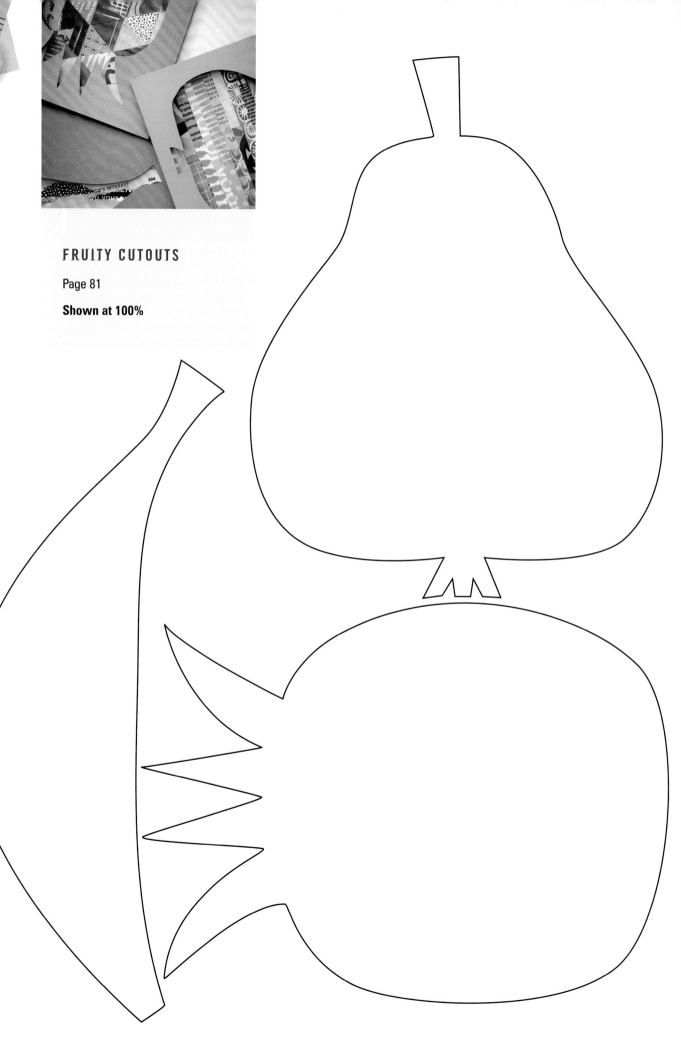

FRUITY CUTOUTS

Page 81

Shown at 100%

FOLDED LAMPSHADE

Page 106

Shown at 50%, enlarge by 200%

LITTLE BOXES

Page 39

Shown at 100%

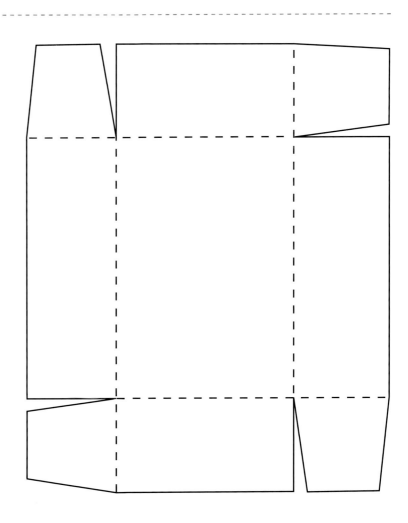

WILDLIFE CUTOUTS (BIRDS)

Page 66

Shown at 100%

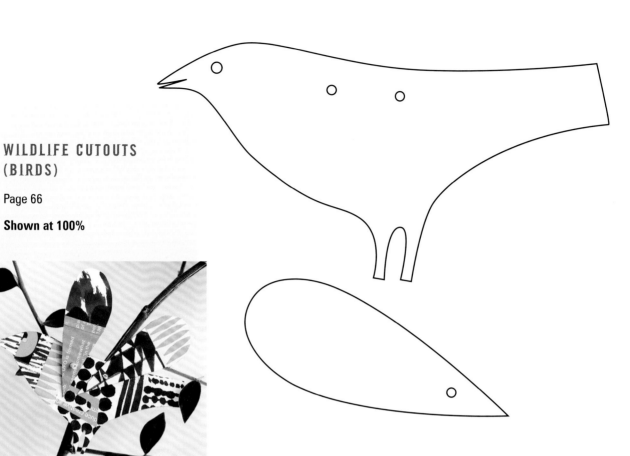

WILDLIFE CUTOUTS (TIGER)

Page 66

Shown at 50%, enlarge by 200%

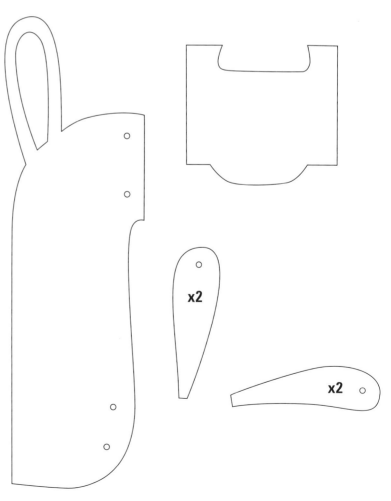

x2

x2

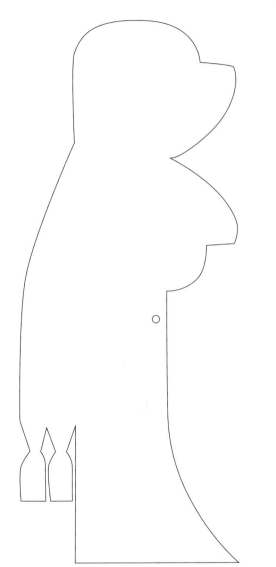

COLLAGE A CABINET

Page 30

Shown at 50%, enlarge by 200%

WILDLIFE CUTOUTS (OWL)

Page 66

Shown at 50%, enlarge by 200%

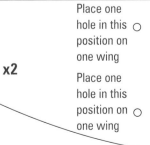

x2

Place one hole in this position on one wing ○

Place one hole in this position on one wing ○

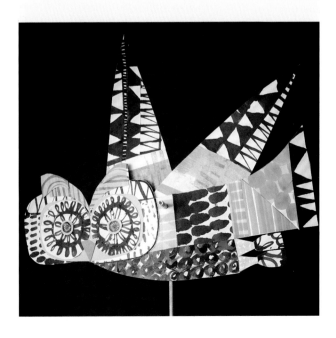

U.S. SUPPLIERS

A. C. Moore

www.acmoore.com

Art Supplies Online

www.artsuppliesonline.com

Hobby Lobby

www.hobbylobby.com

Jo-Ann Craft Store

www.joann.com

Michaels

www.michaels.com

Paper Source

www.paper-source.com

U.K. SUPPLIERS

Cass Art

www.cassart.co.uk

Crafty Devils

www.craftydevilspapercraft.co.uk

Falkiner Fine Papers

store.bookbinding.co.uk/store

Hobbycraft

www.hobbycraft.co.uk

Paperchase

www.paperchase.co.uk

Suppliers of Royalty-free Images

(See page 20, for information on downloading and using royalty-free images)

pixabay.com

doverpublications.com

INDEX

abstract collage: abstract pots 64–5

bright abstract pillow 70–2

large-scale abstract 54–7

armadillo fabric wall hanging 78–80, 119

bags: collaged tote bag 58–9

party bags 101–3

birds: geometric bird 92–4

textural bird 48–50, 120

bouquet, spring 116–17, 123

boxes 39–41, 125

cabinet, collage a 30–2, 127

cockatoo wall art 33–5, 120

composition 21–5

critters, scrap-paper 87–9, 122

cutouts: fruity cutouts 81–3, 124

wildlife cutouts 66–9, 126

ephemera, collecting 18–20

fishy place mat 73–5

flowers, decorative flowers and leaves 98–100, 121

framed layers 36–8

fruity cutouts 81–3, 124

garlands, party 113–15

geometric bird 92–4

gift tags, luggage-label 60–3

giftwrap 76–7

gouache 13

journals, travel 51–3

lampshade, folded 106–9, 125

layering 26–7

luggage-label gift tags 60–3

montages: montage mobile 90–1

photo montage 84–6

name in lights 95–7

notebooks 42–4, 119

travel journals 51–3

offcuts 17

oil pastels 14

paper 10, 13, 15

party bags 101–3

party garland 113–15

photographs 16

photo montage 84–6

photo wall hanging 45–7

pillows, bright abstract 70–2

place mats, fishy 73–5

postcards 16

pots, abstract 64–5

snail mail 110–12

spring bouquet 116–17, 123

stacking block collage 104–5

techniques 10–17

templates 118–27

textural bird 48–50, 120

tools 10–17

tote bag, collaged 58–9

travel journals 51–3, 123

typography 15

wall art: armadillo fabric wall hanging 78–80, 119

colourful cockatoo 33–5, 120

photo wall hanging 45–7

wildlife cutouts 66–9, 126

ACKNOWLEDGMENTS

I have always wanted to write a book dedicated to one of my favorite subjects—collage—so I am thrilled that CICO have given me the opportunity to do so. It is always a great pleasure to work with the whole team and I want to thank everybody. Particular thanks go to Cindy, Penny, Sally, and Kerry. Thanks to Carmel for making everything run so smoothly, and to Anna, who helped with the final stages. Thanks to Anna Southgate for her careful editing and attention to detail. Thank you to Elizabeth Healey for the lovely design and Johanna Henderson for her brilliant photography. Thanks to my lovely husband, Ian, for turning my roughs into wonderful artworks. As always thanks to Ian, Milly, Florence, Henrietta, and Harvey for all their support, encouragement, and advice.